C000120581

PARANORMAL
BATH

PARANORMAL
BATH

MALCOLM CADEY

AMBERLEY

First published 2010

Amberley Publishing Plc
Cirencester Road, Chalford,
Stroud, Gloucestershire, GL6 8PE

www.amberley-books.com

Copyright © Malcolm Cadey 2010

The right of Malcolm Cadey to be identified as the Author
of this work has been asserted in accordance with the
Copyrights, Designs and Patents Act 1988.

All rights reserved. No part of this book may be reprinted
or reproduced or utilised in any form or by any electronic,
mechanical or other means, now known or hereafter invented,
including photocopying and recording, or in any information
storage or retrieval system, without the permission in writing
from the Publishers.

British Library Cataloguing in Publication Data.
A catalogue record for this book is available from the British Library.

ISBN 978 1 84868 176 7

Typeset in 10pt on 12pt Sabon.
Typesetting and Origination by FONTHILLDESIGN.
Printed in the UK.

CONTENTS

Preface 7

Introduction 11

Prologue 15

The Butterfly Legend 19

Things That Go Bump 43

The Grey Lady 79

PREFACE

England is a country rich with areas of natural beauty, a colourful history and many legendary occurrences. The West Country, apart from being very scenic, is well steeped in mystery. Here you will find many treasures of myth, legend and magic.

There is the legend of Camelot, King Arthur and the Knights of the Round Table. Stonehenge contributes its own mysterious awe, serving as a temple for a Pagan religious society, namely the Druids, who still hold ceremonies there. There is also the Avebury Ring, a huge circle of large stones, with just as much mystery as Stonehenge, and Glastonbury Tor and the ruined Abbey where it is reputed somewhere lies buried the Holy Grail. Invisible but powerful ley lines, both benevolent and malignant, crisscross the landscape, adding their own invisible influences to the atmosphere. Also, mysterious events are pre-dominant; the Warminster area is famous for swarms of odd sightings in the sky (UFOs), and a large influx of complex types of crop circles. Can they all be hoaxes, as no one has been caught making one and never has an incomplete one been found? If nothing is satisfactorily proved wrong then it becomes a mystery, and you could say the West Country has more than its fair share of them.

In the time of pre-history, the elders of mankind understood the magic and workings of nature and they utilised these powers into their magical religious practices. They either discovered or they created straight lines of force that radiate from set points and after forming a geometrical pattern usually a triangle, return back to their source. Stonehenge, Avebury Ring and Glastonbury Tor all radiate these lines. Some are hundreds of yards long but the majority are scores of miles long.

Today the average layman does not know the magic and the powerful influence that these mysterious lines possess. It is believed that the druids may have this knowledge and that the travellers who flock to the West Country to celebrate the Summer Solstice may have some fragments of this knowledge. According to the metaphysicians, dowsers and the diviners, the width of the line determines its power; the narrower the line the more powerful the line and contrary to what should be, the malignant lines are more powerful then benevolent ones. Consequently, evil is stronger than good, or so it would seem.

Although in pre-history mankind understood the workings and magic of nature, they could not read or write so the knowledge of the elders was passed down to the juniors by word of mouth. However, due to wars, famines, and the natural disasters that create the flotsam and jetsam of human society there came a time when the information and knowledge of ley lines was lost in the mists of time. Gradually civilisation grew and hamlets, villages, towns and eventually cities were built on top of these invisible lines with no one being aware that they existed.

In these spreading societies, there would be religious leaders and subconsciously they would build their religious building on top of a benevolent ley line without being aware of its existence.

If a ruler is placed on a benevolent ley line shown on a map and a line drawn, the line will intersect exactly the centre of church, chapel, synagogue, temple, mosque, shrine and any building connected with religion. The line, then forming a triangle, will return to its source going through centre after centre of religious buildings. As these buildings are not only separated by scores of miles of space they are separated by hundreds of years of time. No coincidence could produce this effect.

Another anomaly of these lines is that they apparently transmit a power that has invisible influences, as do the acupuncture lines that criss-cross the human body, for years scoffed and ridiculed but now accepted by the Western medical boards. So are ley lines, the acupuncture lines of the earth, and could it be by intercepting these lines like the needles in acupuncture we could eliminate all negative aspects of human life. Maybe this should be investigated.

Tucked away in the South West of England lies the county of Somerset; a county of hills, dales and picturesque undulating landscape views. Twelve miles to the south of Bristol is the beautiful Georgian city of Bath, a unique jewel in its own showcase, the wonderful countryside of the West Country. Bath did not just appear as a beautiful city, the first construction site took place in the first century AD.

In the first century, the Romans occupied England and they discovered in the South West area natural hot springs that bubbled up hot water continuously. This water was (and still is) at a constant temperature and is very mineral rich. It was found that the waters had curative powers so they constructed ornamental baths around the spring of hot water and a town called Aquae Sulis grew around this gift of nature.

In the sixteenth century, Bath Abbey was finally constructed and in 1776 the ornate Guildhall was built.

As the eighteenth century dawned, four men helped transformed Bath from a small, dirty little market town of only 23 acres across into the beautiful Georgian city we know today, with its Crescents, Paragons and lines of symmetrical beauty for which it is now world famous.

Under the influence of one man (Richard Beau Nash), Bath became the centre of the social universe.

We have to thank John Wood Snr, chief builder/architect of Bath, for most of the beauty that now surrounds us. However, the mystique of the Druids, the majesty and awe of Stonehenge, and the mystery and power of the ley lines influenced him and he cleverly and magically interwove some of this magic into some of his more famous structures. His architecture is beautiful to look at but behind some of his structures, a very strong and active psychic influence exists.

The most famous landmarks of Bath are the Royal Crescent which is joined to the Circus by Brock Street, a short but straight street. Brock Street lies on a powerful, narrow malignant ley line; the most powerful kind. Apparently this configuration is a copy of a druid sign of power, a crescent moon attached to the sun by a line of force. The crescent equals the moon, the sun is the Circus and both are joined by Brock Street which is on a ley line (line of force). The Circus is also alleged to be a copy of the plan of Stonehenge, as the circumference of the Circus is the same as the outer ditch of Stonehenge and both structures have three entrance/exits.

To build their edifices the architects needed stone; Bath stone. Ralph Allen owned the stone quarries that supplied the soft limestone with which to build the beautiful Georgian city that we have today. Ralph Alan developed the first postal service and created a stagecoach connection between Bristol, Bath and London. He also introduced a rudimentary form of law and order. So now civilisation was coming into this slowly growing city.

Now we come to Richard Beau Nash, clever with both wit and tongue. He came to Bath completely penniless, having been thrown out of a naval college for some sort of foul deed, but he spoke to the right people at the right time and said the right things to elevate himself to the top of the hierarchy. He came to Bath in 1705 when Bath, as a spa or resort, was falling rapidly out of favour and was in a state of neglect.

He manoeuvred himself into the upper echelons of the ruling bodies and with his powerful personality reorganised both the city and its elite populace, dictating and controlling how the social hierarchy dressed and behaved; where they went and when they went. He organised and produced every social function that took place; the balls, the parades and the social gatherings. He even visited and banned the duels which took place in an area of Bath.

After witnessing a duel with swords he furiously denounced them as barbaric butchery and banned them, whereupon an aristocrat called him a coward and slapped his face. Beau Nash slapped him back and accepted the challenge. They fought a duel in Orange Grove and fought for twenty minutes until Beau Nash received a wound to his arm. He stepped out of sword range and, stating that he had proved he wasn't a coward by taking part in a duel, he then proceeded to ban them.

At certain times of the day a bell would ring and all the social butterflies would dash down to (Mrs A) wearing a certain form of dress. There they would have probably a drink of brandy and ginger biscuits but when the bell rang again they would all dash home get changed and run down to (Mr A) and have crumpets and coffee and so on. Even royalty coming to Bath would obey the dictates of Beau Nash as he was such a powerful entity. Once at a ball he refused a request from a princess to dance with him as he had more important things to attend to.

Bath, under the influence of Beau Nash, was now the centre of the social universe, a beautiful city full of life and vitality, where the cream of society came to see and be seen; however, not only did Bath become the epicentre of the social world it was also the Monte Casino of Europe, as Bath was also a gambling city. Amid all this activity, gaiety, pomp and circumstance there were hidden forces operating, Bath was building its own reputation as it was, and still is, a very much haunted city.

Bath stone, of which Bath was built (soft limestone), has a certain vibration rate that has, in metaphysical circles, the exact vibration rate to absorb and store any traumatic event that takes place. It appears that somehow it stores this trauma like a video recorder and when all the same conditions such as temperature, time, and humidity are exactly the same as when the event took place, it will replay it and a smell, a sound or a vision will be reproduced just as was when the trauma took place. This accounts for some of the many ghostly sightings that occur in Bath.

In the 1970s, Margaret Royal, a very psychically knowledgeable lady in Bath, began to investigate and acquire stories from witnesses of these paranormal events. She became very well known in the city and was constantly summoned to the radio stations and the TV stations to relate her latest findings.

Then in the company of her close friend Hilary Bolwell, also a psychic sensitive, they began to unearth a wealth of ghostly occurrences in various sites in the city. During

their tour of Bath to the various haunts recommended, one or both of them would see, sense smell or be aware of phantoms or shadows of the past. Eventually they discovered an area in Bath which is so powerfully psychic that ordinary people with no psychic training whatsoever, with the right guidance, can be aware that there is more to heaven and earth that we normally know about.

They also discovered that the house of Beau Nash had more than its fair share of psychic phenomena and ghost sightings. The house of Beau Nash is now the Garrick's Head public house, named after the leading tragic actor of the eighteenth century.

Eventually Margaret Royal decided to create a ghost walk, starting from the Garrick's Head and heading into the most haunted parts of Bath, relating the various ghost stories that she had uncovered *en route*.

Then it was discovered that the Theatre Royal Bath shared some of the same ghosts as the Garrick's Head. On investigation it transpired that the reason for this was that Beau Nash's house now incorporates both the Garrick's Head and the adjacent Theatre Royal which are now two distinct and separate buildings.

In 1978, I became a front of house employee of the Theatre Royal. I was impressed by the loyalty of all the staff that worked there. It wasn't so much a job as a way of life. I was soon informed of the strange events that took place in the Theatre. I heard many tales of weird and ghostly encounters which I took to be the reactions of an over active imagination. That is until I had my very first encounter with something a bit more ghostly than the normal activity of the Theatre Royal. I then realised that the Theatre was really and truly haunted and that I had had a paranormal encounter.

In the 1980s, the Theatre had to close to refurbish the unsafe stage and fittings. As the theatre needed at least 2 million pounds to refurbish its ailing stage structures, the future of the Theatre Royal looked very bleak indeed.

I then realised that all these stories of mysterious goings on would vanish into the mists of time as the Theatre closed and the staff scattered taking their stories with them. The thought of these wonderful stories disappearing seemed a shame, so I advertised, asking anyone who had had a psychic experience in the Theatre to contact me.

Within a short space of time, my 'phone kept ringing; letters appeared every day, some from ex-staff from years previous. Within a short space of time, I had in my grasp a multitude of ghost stories relating to the Theatre Royal Bath. Each story I vetted as far as possible by checking the witness statements with other people there at the time, to satisfy to myself that something did happen. Most of the one-off sightings I discarded as there was no one to back up what they allegedly saw or experienced. So the stories included have been filtered and are as authentic as any personal experience can be. Bath is a truly haunted city, but I believe that the epicentre of the ghostly happenings lies squarely in the Theatre Royal.

INTRODUCTION

This book is a collection of authenticated ghost stories from the Theatre Royal Bath. It makes entertaining and thought provoking reading. However, if you would like to go a little deeper into the subject and try to fathom some form of logic to these stories, please continue reading this introduction. If you are not really interested in the whys and wherefores then skip this part and go straight to the **prologue**.

Are there such things, and if so, what are they?

In the twenty-first century, run by computers, lasers, and technology, it seems all is clear, scientific and accountable. There is a logical, physical explanation for everything.

Unfortunately, or fortunately, depending on your point of view, all is not as clear cut as the sciences would like.

Computers speed through countless mathematical calculations and create, plan or solve problems and send electronic mail across the globe at the speed of light. This is all very precise and scientifically correct except for one drawback. The computer doesn't actually know anything, it only knows what it is told to know, it only does what it is told to do. It cannot think, and it is not aware of itself.

That superior computer, the human brain, programs every operation that a computer performs. A computer can use programmed artificial intelligence and act randomly, but only when instructed. It cannot comprehend the abstract or understand the spiritual side of life and it cannot reason. Computers are material and all material is inert. This includes the human brain, for this is also inert and unable to operate by itself; just like a computer, the brain itself needs an operator.

The brain's operator is the mind, your mind. Your thoughts operate your brain. The computer's operator is you; your brain's operator is your mind.

The reason I stress this simile of computer and brain is to make the point that your brain is not the 'you'. The part of you, which thinks I am I, is your controlling thought and thought has no atoms, thought is immaterial, it is etheric. It is a force that intermingles with and influences the physical world, as we perceive it.

If a computer malfunctions, no matter how hard the operator tries all the intelligence inputted is transformed into a rubbish output. If the brain has physical damage or is just too old to work properly, no matter what the mind inputs, the malfunctioning brain fouls up the whole system. A failure of a computer's memory system is on a par with the memory loss in senility. This would explain mental illness and senility. The mind cannot

communicate through a malfunctioning brain.

Providing that the brain is fully functional, the human mind comprehends, reasons and rationalises every item of information it receives. It has multitudinous emotions, ranging from ecstasy to absolute misery, and abject fear to fearlessness. It can recognise beauty and be revolted by ugliness. Most important and more to the point is the one facet of human thought that is common to all, a subconscious awareness of a power unseen; a powerful unseen life force, which permeates everything that we know.

The many various religions label it differently, but whoever or whatever is right, mankind senses the existence of a power or life force of which we are all part. This power is hard to interpret or comprehend; nevertheless, all mankind north, south, east and west know it is there.

All material is inert, therefore the physical brain cannot be aware of all this by itself. The brain needs the mind that is you to operate it. The power that drives and operates the brain is you. You exist, you think and reason but express yourself through the brain and the body.

There are no atoms in a thought or a dream; only energy, the energy of life, the life force, the life force that is you.

Your identity which you relate to as I is not your brain or your body but awareness, and awareness is a thought, and thought has no substance.

What is your body? It is a mass of atoms, a complete universe in miniature; a universe of atoms that is activated and controlled by what? It is controlled and animated with spirit, spirit which is you. You are spirit, but you need a physical body to operate in a physical world. However, you can and do exist without it.

'Out of body experiences' are an example of this and it happens to more people than you think. Sometimes it is triggered off in a near death experience; people who are comatose can describe everything that happened around their unconscious body. It can sometimes happen spontaneously. I can verify this as it has happened to me, and it can be a scary event. Not only is your consciousness adrift from the body, time and distance are of no avail. I once witnessed an incident which did not happen for a further week and it was correct in every detail. All people that have had this experience know for a fact that they are more than the body, they know that they can exist without the body, thus all fear of 'Death' is removed. I suppose in that sense we are lucky.

As man evolved, some sort of order was needed to control the tribes of different species of humans. There had to be leaders and rulers. These were the older, wiser generation and became known as the elders. These wise men would think, rationalise and come to certain conclusions relating to this unseen power which appeared to be a guiding force.

Unfortunately, in different locations of the planet they all came to different interpretations of this same power, and so various beliefs grew from the still unknown ultimate truth.

These wise elders, believing that they alone had solved the ultimate truth, passed down their version of truth plus their own biases to their followers, complete with a set of rules and rituals to abide by.

Some believed in re-incarnation, such as the early Christians (Cathars), later suppressed as it diminished the power of the hierarchy. After all, if you have your own proof, why bother with a king or a priest.

My personal belief, after several years investigating life and its meaning, is the fact

that we, that is you, have always been and will always be, in some form or other. The part of you that thinks – 'I am I' – is indestructible.

You may or may not take comfort in the alleged fact that you are here forever and ever. I'll rephrase that; you will not be here specifically, but you will still exist in a dimension, which at this time we know not. Or as a wiser man has said, 'Through a glass darkly'.

All very well but where do ghosts fit in this wondrous plan?

There are various categories of ghosts or paranormal activity. A ghost is a form of activated energy that becomes a tangible thing, whether it is objective or subjective is not known. Some are nothing but shadows of the past; just that, shadows, there is nothing there but an image, a stamp on the atmosphere. Some appear to have an apparent thought process and some seem to be fragments of a personality. Others appear to be random shapes.

Do not confuse spirits with ghosts, they are totally different. A spirit is a living entity usually recently dead in the physical term. On occasion at the death of a loved one, the living spirit returns to comfort, to re-assure by dreams, by sightings, by attention seeking events, or guidance to circumstance that will comfort and reassure. When the bereaved can eventually handle their grief, they depart and progress to whatever is the purpose of everything.

So do not grieve too long as you will be reunited with the same people that you love and they loved you; love is eternal. In religious terms, 'God is love' rings very true.

So when one dies they don't automatically become a ghost. Everybody's destiny is not to drag rusty chains down a dungeon corridor. No, it is to progress to higher echelons of life.

However there is a separate dimension to this life and death mystery, and that is the paranormal, where energy in a different form manifests into the physical world. The most elusive and the hardest energy to fathom is the poltergeist or mischievous ghost. These entities are in a variety of different categories, from happy and friendly to downright terrifying.

These phenomena seem to be a fragment of a personality as they repeat over and over a facet of the human mind, such as mischievous, spiteful or annoying. The one thing in common is it is attention seeking. There is no record of proof that suggests that any paranormal force can physically harm any living being.

Most ghosts relate to a trauma surrounding the time, or to the physical termination of the said ghost's body. The event appears to lodge itself in the surrounding area only to replay like an etheric tape recorder when conditions are identical to the time of the event.

The proving of a ghost sighting is difficult. Unless one has had their own personal experience it may prove difficult to really believe; convincing others that a ghostly encounter was not a dream or over the top imagination can prove very difficult. In the end, the recipient must believe that the witness is completely and utterly truthful and did not imagine it, which is not easy.

However, because of the numerous witness reports over an extended amount of time it does give credence to the existence of paranormal activity in the Theatre Royal Bath.

Are they good or bad?

Neither! There are no evil goblins or demons; these are man-made names that religion used to frighten the peasants with.

No, all you have is a positive or negative energy. An eminent metaphysician once told me that if you are aware of a presence all you do is say, 'Can I help you?'

If it is a positive force you will feel calm and relaxed and may benefit from a helpful entity. If it is a negative or neutral force being nice is an anathema to it; you are expelling or excommunicating it from its own truth and nothing will happen either way, so you can't lose.

The witnesses to some of the peculiarities in the Theatre include well-known names such as Dame Anna Neagle, Leslie Crowther, Larry Grayson, Bill Lynton, Avril Angers and Bill Owen. Their experiences are reinforced by front of house staff, back stage staff, office staff and patrons from both ends of the earth. One witness was only six years of age, which makes her innocent testimony very convincing.

Whether you believe in ghosts or not is completely irrelevant, as ghosts exist or don't exist in spite of what you may believe or do not believe.

Just for the record, the very earliest written recordings of spirits or ghosts were transcribed on clay tablets dated 2000 BC in Nineveh, a ruined town in what is now Iraq. That was 4000 years ago, and since that time from every quarter of the globe there have been hundreds of thousands of ghost stories from every walk of life.

Now if, out of all these countless stories, one, just one, has one grain of truth in it, then yes there are such things.

All that I can do now is to present to you the authenticated reports from ordinary people with no bias or pre-convictions, who saw, felt, or knew that something was odd, different, or unreal; it was ghostly. As the same or similar experiences have been shared by so many over a long length of time does makes them feasible. These are the personal experiences of paranormal activity in The Theatre Royal Bath.

Although the Theatre Royal appears to be the epicentre of the paranormal in Bath, I have included after the Theatre stories, some brief glimpses of the paranormal in the City of Bath.

The energy is currently active.

Now let us investigate the strange happenings in the Theatre Royal Bath.

PROLOGUE

There has been a Theatre in Bath since the eighteenth century, although not always on the present site. The original Theatre stands in Old Orchard Street, and was granted a Royal patent in 1768, becoming the first Theatre of the provinces to receive Royal assent. George Dance and John Palmer built the present Theatre in 1805. Incorporated into the new building was part of Richard (Beau) Nash's house, which stands on the site. Since it was built the Theatre has had a varied and sometimes disastrous career. During the eighteenth century, many famous players performed here, including Sarah Siddons who played here from 1778 until 1782 before moving on to London's Drury Lane.

On Good Friday in 1862, a mystery fire completely destroyed the interior of the building; however, it was completely redesigned and restored within nine months by C. J. Phipps, who was only twenty years old at the time. Apart from redecorating in 1892 and 1974, major renovations in 1981-2 and re-seating with improvements in 1999, the original Theatre remains to this day. The present day Theatre Royal enjoys top class productions with all the famous names. In 1980, the National Theatre and the Arts Council agreed to make Bath its main regional base for its middle scale productions. This will mean regular visits by this most foremost of Theatre companies and the previewing of productions prior to their opening in London's National Theatre.

The 'Theatre Royal' is famous, successful, attractive and popular. It is also very haunted.

You are about to explore the dark side of the Theatre. Drifting down dim corridors and the empty auditorium, where in the dark corners there lurk creatures of no set form. These are the living shadows of the past. There they wait, watching, like spiders in the night, waiting for the right moment to materialise into whatever odious form they decide will be the most effective.

The macabre happenings related in this tour are the authentic reports gathered over the years from staff, cast and members of the audience.

You will meet the 'Grey Lady', the Theatre's principal ghost, who also haunts the once actors hostel next door, The Garrick's Head.

It is no co-incidence that The Garrick's Head has its own store of alarming stories.

You will find food for thought at the extraordinary happenings in the 'Legend of the Butterfly'. Although not a ghost story in the usual sense, the eerie events surrounding this legend are sometimes more awesome than the appearance of a gruesome phantom. It certainly proves a power at odds with the force of nature, as we perceive it.

The stories about to unfold are interesting, puzzling and sometimes chilling.

Put together they make an entertaining adventure.

The Theatre is now open to your imagination.

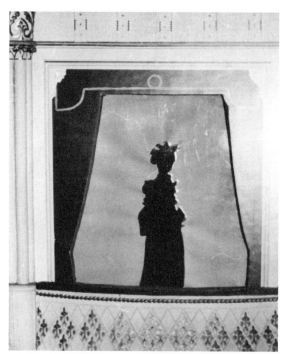

Left: The Grey Lady. *Right:* Garrick's Head.

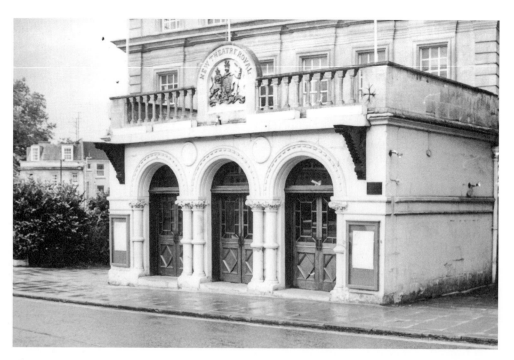

Theatre 1980.

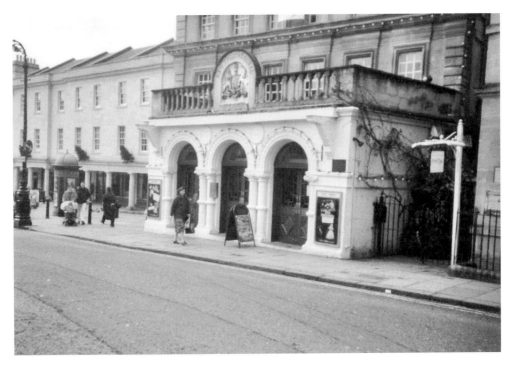

Theatre 2009.

I dedicate this book to Hilary Bolwell and to the memory of Margaret Royal who introduced me to the Bath Ghosts and all my friends seen and unseen at The Theatre Royal Bath.

NOTES

- The events in this book are NOT in chronological order.
- Names have been changed or omitted by request.
- The scenery may change but the Theatre is constant.

This book is your ticket to the show.

Move forward and settle into the pages.
The curtain is rising for you to experience

PHANTOM PERFORMANCES

PHANTOM PERFORMANCES

Margaret Royal, Famous Authority on Ghosts, experienced the same strange energy that terrified Andy Paul and Marie. She informed the author that the negative power was strong enough to make her flee the Theatre.

This was after a séance had been arranged on stage after a performance. Apparently a table used to contact any possible spirits suddenly rose up throwing off all the hands on table and kept going up until it reached the flies from where it gently returned back to its normal rest on stage. One actress who was taking part had hysterics and rushed out the Theatre. Margaret felt such a powerful presence that prudence suggested that she departed from the Theatre; this she did post haste.

The Bath city landscape.

THE BUTTERFLY LEGEND

If I am found devoid of life.
Be sure my tidings are of strife.
If my life be at its end.
Misfortune or death is my portend.

When pantomimes open, all await
For me, the butterfly of fate.
If l am flying high and free.
Success, will surely follow me.

In life or death I prophesy.
In the earthly guise of a butterfly.
Fate's messenger is my destiny.
For the Theatre's soul, is alive in me.

Malcolm Cadey

THE LEGEND OF THE BUTTERFLY

Of all the stories of ghostly happenings in the Theatre surely the butterfly phenomenon is the most authenticated and amazing. Its weird happenings and prophecies have been witnessed by hundreds of people, including stars, audience and staff. There is no doubt that something powerful is at work.

The legend all began in 1948 when a new pantomime, Aladdin, was being rehearsed. To add to the colour and pageantry of the pantomime, a spectacular ballet scene was devised. Although the scene was to the story of Aladdin it was hoped to be the highlight of the show.

The chorus girls were all dressed as tortoiseshell butterflies and a large colourful set piece was constructed in the shape of a large butterfly. It would be illuminated and the girls would dance around it. It was about four metres across and two metres high. The manager, producer, was certain that this ballet would add novelty, colour and beauty to his pantomime. The cast and staff were sure he was right.

It was carefully choreographed, the dancer's dresses were of a filmy, beautiful texture and the girls also wore a pair of gossamer wings. It all looked good and all seemed to be going well. One day, just before the start of a ballet rehearsal, a dead tortoiseshell

butterfly was found in the costume room. Now, as the majority people connected with Theatres are very superstitious, to find a dead butterfly in an area of butterfly costumes appeared to be a bad omen.

The girls were not happy, pointing out that to find a dead butterfly when they were dressed and acting like butterflies looked to them like a warning off.

What utter nonsense, stated the manager, and made them carry on rehearsing. However, things now began to go wrong, it became hard to get the act together, music went missing, scenery fell down, dancers were taken ill, and the atmosphere of the ballet had changed. On top of all that, more dead butterflies were found on stage prior to rehearsals. They struggled on, trying to get it right, until one day, as they came on stage to rehearse they found three dead butterflies in a perfect triangle in the centre of the stage. That was the last straw and the dancers adamantly refused to carry on with this dance which was obviously cursed.

The manager was furious and a huge row broke out on stage as he ordered them to dance to which they stubbornly refused. Eventually, he told them to go back to their dressing rooms to calm down and come back in half an hour where, whether they liked it or not, they were going to do the butterfly Ballet. The girls, all of whom were angry, stormed off stage and went to their respective dressing rooms. One girl who was really furious rushed into dressing room number six and in her temper slammed shut the door with great violence.

Unfortunately, the draught from the slamming door flared the gas fire into the room; a large tongue of flame leapt out of the fire and ignited the filmy dress worn by the dancer. The girl, badly burned, was rushed to hospital and she never danced again.

So, now there had been a tragedy, the girls were emphatic that as far as they were concerned there was to be no butterfly ballet. The manager didn't pursue the matter for about a week and then called a meeting on stage. When the girls arrived they were not pleased to see the large set piece butterfly positioned on stage.

The manager called them on stage and told them that yes, there had been a dreadful accident but it was sheer co-incidence, it was nothing to do with butterflies, dead or alive. He then strode up to the set piece butterfly and told them, in no uncertain terms, that there was nothing wrong with this butterfly; he punctuated his speech by punching the butterfly to emphasise his point. Suddenly, he swayed then staggered back from the butterfly, and as he turned slowly to look at the assembled girls his face was red and he appeared confused. He gasped for air and then began muttering half to them and half to himself; it was hard to detect what he was saying but quite a lot of cursing was interspersing his sentences.

He then stood still and seemed to stare into space; he turned and looked back at the butterfly then slowly turned his head and stared at the girls, and without a word or a backward glance he walked off stage. The girls stood there wondering what to do. After ten minutes they dispersed, puzzled at the change in his attitude and his sudden departure from them.

The next day the news came that the manager had been taken to hospital suffering from a heart attack, which had been triggered off by the stress on stage while he was in the middle of his harangue against the butterfly.

Several days later he died.

So! Now there was a double tragedy connected with the butterfly. All involved were now convinced that some power revolving around the butterfly was to blame and the setpiece butterfly now standing on stage was an object of fear to all in the Theatre.

A new manager took over and was immediately taken to task by the dancers about

the strange events surrounding the butterfly ballet and their determination not to participate in it even if it meant their jobs.

After listening to the events that had taken place and seeing the fear and determination in the girls' faces he made a decision; he scrubbed the ballet scene.

Unfortunately there remained a problem, as the set piece butterfly was still on stage and such was the fear it generated that nobody would go near it.

One morning, as the cast were sat in the stalls auditorium discussing this problem, a member of the stage crew, a little bit braver than anyone else, suddenly walked on stage and up to the butterfly. There he stood right in front of this large representation of a butterfly, and all that witnessed this were in trepidation as to what may happen.

The stagehand spoke to the butterfly.

'Butterfly! We do not know who you are, We do not know what you are, We do not know why you are.'

All we do know is that you have powers that we cannot comprehend; we also know that you are in strong rapport with the spirit of the Theatre so we respect your knowledge and wisdom. However, as you must now know, this is a Theatre and to exist we must put on productions and shows. So I am afraid we must move you off the stage. But listen, we will put ropes around you, we will hoist you gently into the flys and there you will remain as the guardian or the soul of the Theatre, and I promise that no show will be activated unless you are there to oversee it.'

With these brave but intelligent observations ropes were attached to the butterfly and it was hoisted gently up into the flies were it remains to this day.

It doesn't end there, as since that time the butterfly has sent its messengers; in the guise of real butterflies. A dead butterfly foretells disaster or death, while a living one signifies success.

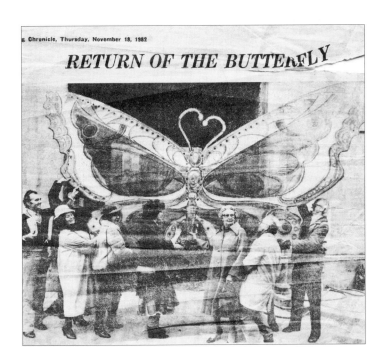

Butterfly return.

The legend was born.

Since that time, a living butterfly will only bless the pantomimes that are destined to be an outstanding success. Pantomimes usually open on Boxing Day, which is in the middle of winter, so a flying butterfly is an unusual event in itself. If no butterfly appears something will be amiss. Illness, accidents or lack of support for the show are the usual catastrophes that occur in the absence of the butterfly. There are countless stories of the butterfly in the Theatre; to relate them all would take a book in its own right, so I have selected some of the most astonishing and well-authenticated tales. These amazing stories are proof indeed that a power above the normal sphere of natural law exists in the Theatre.

This is an article in the *Bath Chronicle* with a photograph describing the return of the butterfly back to the Theatre after renovation.

'A giant butterfly prop was returned to its resting place high above the stage yesterday.

For the past 12 months, while restoration has been going on at the Theatre, the winged creature – believed to have magical powers – has been looked after by the Bath Operatic and Drama Society. They have stored it and made some repairs. But with the first night of the new season in the renovated Theatre only days away, it was time to bring back the Legendary Butterfly.

The Theatre's tradition has it that every year a live Butterfly appears during the Pantomime season – and that if no Butterfly flits across the stage, doom will follow. This year's Pantomime is Cinderella, and the "Guardian Butterfly" seems to be doing the trick. Bookings are said to be good so far.

It may be prudent to point out that after this photo was taken and the butterfly passed into the realms of the Theatre, not one person on the graph would go anywhere near the butterfly. The reason being that now it was back in the Theatre the butterfly had once more become the magical creature of legends.

During the performance of Cinderella a living butterfly settled on the table where Bill Owen was having a meal in the Theatre Vaults.

'Well, that's confirmed our success,' he told a waiter. Of course he was right, the show was a success.

The following stories will confirm that the legend is an active force.

MR BERNHARD IS UNWELL!

The man sat on the floor of the bar, obviously fed up. He picked up a newspaper and began to read it. The man looked remarkably like Peter O'Toole, which was not surprising as it was Peter O'Toole.

The current play this week at the Theatre Royal was a pre-London launch of the play *Mr Bernhard is Unwell*. The star performer was the very famous actor Peter O'Toole.

The Theatre was packed as people flocked to see, not so much the play but to see Peter. This was all very well but the producers were a bit worried.

The play had been opened in Bath as the Bath audiences were highly critical of all productions at the Theatre Royal Bath.

If the Bath audience liked it then fine, it would be a success elsewhere. This production was destined for the West End; however, the enormous cost it would entail to produce it in London meant that it had to be a success with the patrons, or large losses of cash would ensue.

So, the decision was taken to open it in Bath. If Bath liked it, fine, send it to London and all would be well. If Bath did not like it, this would spell disaster, so they would cut their losses and close the show for a rethink.

Unfortunately, it was now Wednesday, and the reaction so far had been less than encouraging.

At the back of the auditorium the producers and directors stood, making notes of audience reactions.

Monday night's performance left a lot to be desired; although the play ran smoothly, the audience reaction was desultory. They did not react as the management would have liked. So, scenes were altered, some lines cut, and some lines added.

Tuesday night came, and still it wasn't working to the satisfaction of the producers and directors. More alterations were incorporated into the script, some shortened, some cut and some lengthened.

They were now getting very worried because, at the final curtain, the applause was polite but restrained, the patrons were not over-enthusiastic about the play and it would appear that to send it to London in its present form was to court financial disaster.

In the minds of the management was the seed of failure, as the play was not working as it should. They were thinking that it may be better to stop the production now, and cut their losses.

It was now Wednesday and the matinée performance was in full swing. Once more they all gathered at the rear of the stalls and monitored the audience reaction; it was more or less the same as before.

Then came the bar scene. Peter, in this part of the play, was half-laid, half-seated on the floor of a bar reading a newspaper.

Peter murmured the lines of the play, when from the left hand side of the stage there appeared a moving dot. A tortoiseshell butterfly made its entrance. It did not fly on to the stage; it actually walked on from the left hand side wings.

The lighting operator saw this creature and swung a small spotlight on it as he knew the significance of the butterfly.

The butterfly walked sedately across the stage until it was in line with Peter, who was now very aware that something strange was happening.

Peter, being a true professional, tried to ignore this alien invader that was now dominating the stage. Then, in full view of over a thousand patrons, the butterfly took flight; it flew around Peter three times and then settled on the corner of the paper he was reading. Peter was so shocked that he exclaimed a few colourful words of surprise that luckily only the first two rows heard with any clarity.

The audience sensed that something peculiar was happening and a hush descended onto the Theatre. The insect took off from the paper, flew around Peter three times and then spiralled upwards towards the flies.

One of the stage crew, alerted now by radio messages, looked down and saw the dancing dot of the butterfly flying up towards him.

As it passed him at his level he produced and shone a bright torchlight on the winged creature. It carried on upwards and appeared to settle in a corner of the fly roof.

His eyes never left it for a second, and grabbing a step ladder which was close by and keeping his eye on where the insect was, he climbed up, and keeping the beam of the torch on the area went to grab it, but there was nothing there at all. No butterfly, no nothing; this crew man is still shook up at the disappearance of what he could plainly see.

Back down in the stalls, the play progressed and much to the producers surprise the audience were now reacting as they should have done in the beginning.

The play was working, the punch lines were working, and the emotions were working. Then there came the final test; the play ended and the curtain call came. What happened?

Much to the pleasure and of surprise of the producers the audience came to its feet and gave a standing ovation. The play was a success. It was a hit, the Bath audience liked it, and so it was now safe to send to London.

When it opened in London the *Sunday Mail* headline read:

'Butterfly Blesses Peter O'Toole's Play.'

Needless to say that this play had a very positive run in London and made plenty of money for its investors.

The butterfly had once more left its mark...

Long live the butterfly.

ALADDIN'S BUTTERFLY

Leslie Crowther, the star of the new pantomime Aladdin, put the final touches to his make-up. Soon all the work and effort put into rehearsals would be put to the test. The rehearsals had gone well, the cast were happy, and the atmosphere felt good.

Because of the love and respect that Leslie always commanded, the entire Theatre staff were unanimous in their wish for him to have a successful pantomime. Leslie had not done too well of late, so a successful show now would give his career a boost. Tonight was opening night, and apart from the usual opening night nerves, everyone felt quietly confident that this pantomime of 1979-80 would indeed be a success. However, this was the Theatre Royal and luck, or the lack of it, depended on the whim of the stage butterfly. Many of the staff had told Leslie that to succeed he needed the butterfly to appear alive and well and flying free because that should guarantee success. Happily, during rehearsals no dead butterfly had been discovered, so no bad omen had occurred.

All was ready. The corridor inside the Theatre leading to the stalls was a colourful tapestry of children's paintings, entered in a competition to find a cover for the programs, with the winner having their design printed on all the Theatre's programs for the pantomime. Piles of sweets and trays of soft drinks were ready and waiting. The staff took up their positions and braced themselves, in much the same spirit as soldiers manning the barricades at the onset of a siege. The foyer was a seething mass of closely packed, excited children, held at bay by ropes across the stairs. Eventually, the signal to open the house was given and the ropes came down.

The colourful torrent of chattering children invaded the Theatre. The ushers tried valiantly to cope with the inrush of so many excited children and their parents, who tried to look as if they were not really enjoying it. The stacks of sweets swiftly vanished. Change was dropped and people fell over youngsters scrabbling on the floor for their lost pennies. Plastic cups of soft drinks were drunk, spilt, or put down and forgotten.

Children laughed, cried, got lost or locked themselves in the toilets. It was a noisy, crowded scene of chaotic happiness.

In a previous year, during the pantomime interval, a horde of brownies charged up to a sweet vendor in the balcony. They shoved and pushed to get as close to the tray as possible. The vendor holding the tray of goodies was a rather frail old fellow who lost his balance during all the shoving and pushing of the excited little girls and fell over, scattering all his sweet goods into the corridor and down the stairs. When the poor old chap eventually struggled back to his feet, the brownies had gone, and so had his stock. He never lived down the fact that he had been mugged by a troupe of brownies.

Mary Smith, the house manager, seemed to be everywhere at once. Mary was amazing; she sorted parties out of the wrong seats into the right ones in a twinkling. She would descend on a crowd of milling, agitated adults and children, who couldn't work out where they should be sitting, and with a few curt shouts and waves of her arms, would have them dropping into their correct seats in a matter of seconds.

Mary, in some miraculous way, restored order out of sheer bedlam. Eventually, as the time for 'Curtain Up' drew closer, the flow of patrons slowed down to a controllable number.

Four minutes to go; it was almost time. Mary did a last check by standing in the auditorium of the dress circle to await clearance. When she had received a hand signal from each floor that all was ready (no two-way radios then), Mary would then go to the control box, which was then situated at the rear of the dress circle, and give the all clear

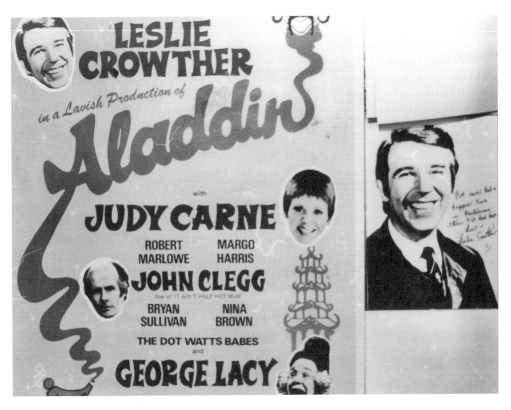

L. Crowther, Panto poster.

to go. The controller would close his door and throw certain switches. The house lights dimmed, and the buzz of the audience slowly died away. There was a brief moment of silence then the orchestra struck up, and the happy bouncing music of the pantomime filled the Theatre. As the overture died away the curtain rose, revealing the colour and splendour of the first performance of this year's pantomime – 'ALADDIN.'

At the curtain rise, an unusual event took place. Nearly all the F. O. H staff left their posts and crowded into the back of the auditorium to watch the opening scene. Although they were interested in the show as a whole, the main interest of everyone was, would a butterfly appear? The show began, and the seconds ticked by with no butterfly. If only one would show tonight, that would really ensure success; however it hadn't appeared yet.

Then a burst of applause heralded the appearance of Leslie Crowther, who, dressed as Wishee Washee, made his first entrance. Bathed in the glare of the limelight, Leslie stood and waited for the long burst of applause to die down. Leslie, however, was so well loved by everyone that they just kept clapping him. Eventually, Leslie raised his arms and tried to stem the accolade; he thanked them profusely for their reception but said:

'Thank you, thank you so very much, but we must carry on with the show.'

Then something strange occurred. Leslie, who had been smiling at the audience, suddenly froze; his smile faded but he remained with his arms uplifted staring up into the limelight. The orchestra conductor, realising that Leslie had frozen and was staring at something over his shoulder, turned and followed Leslie's gaze. He turned to look over his shoulder; then he also froze, so the baton stopped, the music stopped and the dancers stopped. The animated show became a still tableau; there was not a sound or a movement in the Theatre, except one movement.

There appeared, high in the beam of the spotlight, a small sparkling dot. It weaved and turned and danced in jerky, circular motion. The beam of the light made it glitter and shine like a dancing spark. The show was still a tableau. The music had stopped, no lines were spoken, and no dancer moved. In the eerie silence, the only movement now watched by hundreds of eyes, was the dancing of the sparkling object in the limelight.

It suddenly ceased its erratic spiralling flight and, with uncanny accuracy, flew straight to Leslie who was still transfixed by the sight of this winged messenger. The butterfly danced around Leslie's shoulder for a few seconds and then it landed square on his lapel. As it came to rest it spread its wings, revealing the beautiful markings of a tortoiseshell butterfly. Leslie shook his head and slowly raised his hand to remove the shimmering insect. As he did so it fluttered off his lapel and landed on the palm of his hand.

He walked slowly to the wings, holding his outstretched hand with the butterfly perched on it. He approached the stage manager, who was stood in the wings, but as he did so the butterfly suddenly took off and flew straight towards the manager who instinctively held out his hand. The butterfly flew up to his hand and settled on it. Leslie said to take care of this creature and the manager walked off with it.

The manager went straight to Leslie's room and opened the door to go in but the butterfly once more flew off and settled in the corner of Leslie's mirror on the dressing table; there it sat and slowly opened its wings and closed them.

Later on, that room was searched meticulously, but no trace of a butterfly was found. Leslie, on his return to the stage, apologised to the puzzled audience for this unscheduled performance and promised to explain the Legend of the Butterfly at the end of the show. As the first act finished Leslie came off stage, visibly shaken. He told the stage crew

that to see a legend come to life was really scary, but if it were true then the pantomime would be a success.

The pantomime, predictably, was an outstanding success, with full houses right through the season. The show was not only successful, it was one of the happiest the Theatre had experienced. Leslie left a signed photograph for the Theatre; on it is written: 'I have never enjoyed a pantomime so much as I have at the Theatre Royal. Luv, Leslie'. When the season drew to a close and the pantomime came to its inevitable end, both staff and cast felt a real sorrow. Nevertheless, at the end of show party many a toast was drunk to the appearance and blessing of 'The Butterfly'.

Then Leslie made a speech, in which he thanked everybody for their help in making this pantomime so happy and so profitable. He once more thanked the butterfly, but said that its powers were limited because he had gone to the set piece in the flies and asked it to extend the pantomime for two more weeks so as to gain more revenue. However, the management had just informed him that it was impossible as other shows were already booked and it could not be done. Still, the butterfly had done a wonderful job on the show, so thank you very much.

Unbeknown to Leslie, the butterfly had not finished with him yet. Shortly after, he received a 'phone call and was given the position of compere on the TV show *The Price is Right*.

Leslie now went to the top of his profession. Leslie's luck had really changed with the blessing of the butterfly.

THE RE-OPENING OF THE THEATRE

1982, Tuesday 30 November

This was a great day for the Theatre Royal; after Leslie's pantomime *Aladdin* closed in January 1980, there followed a stressful time as the Theatre was now unsafe. The stage apparatus just could not cope with the weight of modern productions and, for safety reasons, urgent replacements and modifications were desired. Unfortunately, all this would cost money and that was a scarce commodity.

Money raising projects were pressed into service, Top Brass and the 1805 Club grants were requested, and donors who loved the Theatre, including myself, assisted in their own way to help raise revenue for the Theatre. The Theatre appeal was launched but the task was daunting. The estimated funds required were in the region of £3½ million to make re-opening a feasible proposition.

If enough cash was not raised, the Theatre would close forever and become a supermarket or theme pub. Top stars came to Bath and held meetings on stage to help boost the effort of the fundraisers and to plead for every effort possible to ensure the continuation of this Theatre's existence.

It is to the credit of the leader Jeremy Fry, the controlling team and the restorers that, by the co-operation and intelligent application of both the administrators and the physical refurbishment, they brought this figure down to £1.8 million, which was no mean achievement.

This brought the figure to an attainable amount. The struggle was hard but on Tuesday 30 November all the efforts were rewarded.

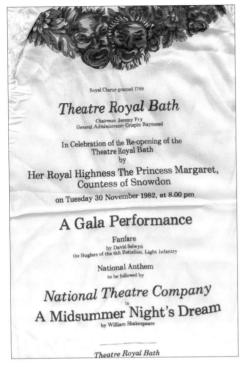

Dramatic history: a playbill advertises the opening performance at the Theatre Royal after it was renovated in 1863

Above left: Silk program for Princess Margaret, 30 November 1980.

Above right: Original program.

At approximately 7 p.m. a loud fanfare of trumpets sounded outside the box office and out of a black limousine stepped HRH Princess Margaret, who was met by the Mayor of Bath; the Theatre Royal Bath once more became a living Theatre.

The production was *A Midsummer Night's Dream* by William Shakespeare.

This was a prodigious production with Edward de Souza and Marsha Hunt, a show befitting royalty. All associated with the Theatre were allowing themselves a brief period of relief as their goal and aim came to pass. The Theatre was alive again.

Unfortunately, it was not out of the woods yet; the Theatre was in debt and a form of bridging loan and leasing instead of purchasing was necessary to enable the Theatre to open at this date.

This money, of course, had to be repaid and the Theatre was still cash starved. After this performance the appeals would continue. There was still a lot of anxiety as whether the Theatre would carry on if the capital diminished. What the Theatre needed was a bit of luck...

Through sheer hard work and determination the Theatre had come so far; all it needed now was a smile from the gods.

However, tonight the house was full, the Theatre was alive, the actors were ready and the Princess was sat in the front row of what is now the Royal Circle, surrounded by garlands of flowers. The drums rolled, the lights dimmed, and the curtain rose on this auspicious production of *A Midsummer Night's Dream*.

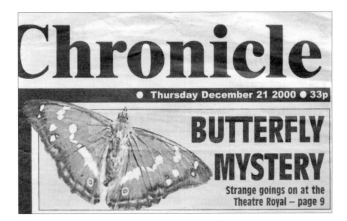

Ghost butterfly, *Chronicle*.

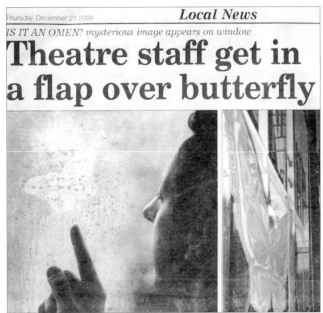

Window butterfly.

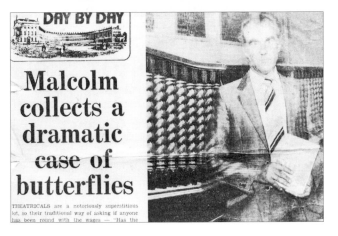

Malcolm's butterfly, *Chronicle*.

The magic on stage was captivating and enthralling. The actors played perfectly, the scenery and the atmosphere made this play an experience to remember.

The show was also watched by members of the front of house teams, they of course were pleased to have work again but they all knew that it might possibly be a temporary circumstance.

Then, to their surprise and delight, there appeared a symbol of what could be their salvation. A third of the way to the top of the stage during the play was a small, hardly noticeable moving object.

It was the butterfly; the winged creature flew round and round the top of the stage right through the performance in a clockwise direction. It did not approach any of the actors because it was not blessing a person; the butterfly was blessing the Theatre. Everyone that understood the Legend of the Butterfly knew straight away that there was no need to worry as the butterfly, by its token of appearance, had sealed the success of the Theatre.

Against all odds, the monies needed were found, and every time a cash crisis appeared something would come from somewhere and the crisis would abate. This was in the form of grants from the arts council, Bath council and even a substantial amount from lottery funds. Also, with careful planning and bookings of shows, in the main, every week most seats had bums on them.

This beautiful Theatre is a success and with the blessing of the butterfly will grow and prosper, for such is the power of the butterfly.

THE BOX

It was cold, very cold; it was February and it was a grey, frosty morning. The stage crew cursed their luck. Who on earth had thought this job up on a day like this? They stood hunched against the cold as Ken unlocked the store that used to be the stables of the Theatre long, long ago. The large store housed loads of junk, old props and countless other bits and pieces that accumulate in a live Theatre.

The management wanted the store cleared, fair enough, but why did they have to organise it for a wintry February morning? Once they started work it wasn't quite so bad; some of the props were heavy and the lifting and pulling soon had their blood pumping round. The courtyard began to fill up.

There were bits of scenery, faded and torn, old curtains, broken chairs, cut out figures and an odd collection of mixed junk or treasures (depending on your outlook), was carried, lifted or thrown out of the stables. Ken came out with a closed box; it was about three feet by two and was made of heavy wood about two inches thick. Complaining about the weight he put it to the side of all the other paraphernalia. After an hour the crew stopped for a smoke, and sat down on the nearest available object. Ken and a colleague sat on the box. While they sat there, they began to speculate what could be inside it. Money? Perhaps some miserly actor had stashed his hoard in a box and left it. Hardly likely, but it was nice to dream. Jewels, maybe, although that didn't seem possible either. After speculating on its contents, the thing to do was to open it and see. By now the rest of the crew had grown curious.

What was in the box?

The box was lifted and placed in the middle of the yard. The lid proved stubborn, so a screwdriver was produced. After a bit of prodding the lid lifted slightly, the crew bent

forward expectantly; it was like opening an Egyptian tomb, and Ken was making the most of the drama that was about to enfold.

'Hey Presto!' he called; as with a final flourish he threw open the lid.

Accompanied by a cloud of dust the lid fell back. To the astonished eyes of the crew something remarkable happened; inside the box there was a movement.

As they watched, through the settling dust, there appeared something. Among the scattering papers there emerged at least six butterflies. At first they were just scrambling about with closed wings as they staggered out of their confinement, but then, finding the wind beneath their wings, one by one they fluttered upwards. The butterflies circled, and then watched by the amazed crew men, like a flock of birds they wheeled in a tight turn and swept in a dancing ball of colour towards the main Theatre building. They paused near the stage-loading bay and then vanished inside the body of the Theatre. The men remained silent as they watched this event.

'Good god, look at that', said Ken, pointing inside the box. Inside the box, now faded and dusty, was a photograph of Reg Maddox (the owner from several decades ago), and written on the photograph was FOLLIES 1932.

As far as anyone knew that box had been there since 1932, yet here it was being opened in 1981, releasing a cloud of tortoiseshell butterflies.

Even in hibernation a butterfly cannot possibly survive for forty-nine years. If by some remote and unlikely event that they gained access to the box, in the month of February it is hardly conducive to them becoming wide awake and able to fly in the cold weather; furthermore, butterflies don't fly in groups like birds. It is just a mystery; just one more of many mysteries that abound in the Theatre Royal Bath.

RICHARD'S STORY, 1999

Richard, the manager of the 1805 club, the VIP rooms of the Theatre Royal, glanced around the tables once more; it was late afternoon and he was making sure that all was ready for a function later on in the evening. Fine, everything appeared to be in order so Richard turned to go out of the dining area, and as he did so he noticed something on one of the tables. Something was moving between the table decorations, something small but colourful. It was a butterfly.

Knowing all about the stories that abounded about the butterfly, Richard was quite amazed to see one in his territory, as he was autonomous from the Theatre proper; however, he respected its presence and curiously approached this messenger of fate.

At least this one was alive so its message couldn't be bad. As he approached the creature it fluttered up from the table and appeared to be flying clumsily. Richard watched as it suddenly descended on a neighbouring table and seemed to crash land on it. Thinking it would continue hurting itself Richard thought that the best thing to do was to let it out the window and let nature look after it. He went over to the table and gently palmed the butterfly, which did not struggle, but just very slowly opened and closed its wings. Opening the window, Richard held his hand out of the window with the butterfly standing on his palm, which was making no attempt to fly away. With his other hand he gently nudged the butterfly to go. It slowly walked towards his finger ends but at every step it lurched to one side. Richard then saw why, it only had five legs, one of its legs was missing.

How strange, thought Richard, and with that the butterfly flew up, danced around Richard's face as if to make a point, then spiralled away up towards the fly tower and vanished from view.

Although Richard was aware of the butterfly's reputation for forecasting catastrophes, as he had already reasoned, as it was alive it must be a positive omen. During the rest of the day, he found the memory of the butterfly's leg kept popping up in his memory, until after a while he began to worry about the significance of this missing leg. Was he going to fall over and break his leg? He began to be extra careful going up and down the stairs just in case the warning was for him. Just after 8 p.m., when all the preparations were complete and the staff were all ready, he received a 'phone call which shocked him.

'Cancel everything, the dinner's off, the show's off; it's all chaos, save what you can of the food then shut down.'

'Good god, what's happened?' asked Richard.

'I don't know yet but get going, I'll get back to you.'

There was a lot to do and Richard concentrated on salvaging as much as he could after having such a large function cancelled. By the time he had done what he could and gone home he still did not know what had triggered off this calamity. It wasn't until the next day that Richard was made aware of the butterfly's message.

The previous evening in the Theatre Royal had been a complete fiasco; the evening's performance had been cancelled at short notice, Richard's function was linked to the audience and guests, some who stayed and some who didn't. Money was lost, as both the Theatre and the 1805 Club had to reorganise and refund disgruntled patrons. It was not a happy night. Later on, Richard was chatting with some of his colleagues and was expressing his concern at the foul up, so he then asked why the show had been cancelled like that.

'Why didn't you know?' answered one of his friends. 'It was Richard Shaw, the main character; you knew that he had a bad leg didn't you? Well, last night just before he was due to go on stage his bad leg gave way, and he said: "There is no way I can do this show, not with one leg missing."'

Richard took a sharp intake of breath. One leg missing; of course, that was the butterfly's message. It was a warning, it had shown Richard quite clearly that the butterfly's missing leg would be of some consequence, and it was.

That very night the show was cancelled with all its upsets and monetary loss because of 'A missing leg' and the butterfly had quite graphically shown Richard, look: 'A missing leg'.

Coincidence? By itself maybe, but in context with all the other butterfly stories, hardly.

When Richard first told me his story his first words were:

'I tell you Malc when I matched the significance of the butterfly's missing leg with the subsequent event with Richard Shaw, it was really spooky. The only thing it got wrong was that it came to the wrong Richard; my name's Richard Taylor not Richard Shaw.'

DEATH AT NO. 6

The dead insect lay there, motionless and dusty, barely discernible from its surroundings. Its once fluttering wings were now stiff and closed, hiding the markings of a tortoiseshell butterfly. It lay on the floor, just outside the door of dressing room No. 6. Anywhere else

it would have passed unnoticed. However, this was the Theatre Royal, and butterflies, alive or dead, were of extreme importance.

John, one of the back stage crew, hurried down the corridor, after making the usual checks before 'Curtain Up' on another matinée performance of the pantomime 'Red Riding Hood'. The pantomime wasn't doing too badly, although no live butterfly had appeared on opening night. As John passed dressing room No. 6, he came to an abrupt halt; he had seen the dead butterfly. He stared at it for a few seconds and his expression changed to one of anxiety. Bending down he gently lifted the small dead creature, and laying it on his open palm, slowly walked back the way he had come. Standing in the doorway of his office, Norman Wooton, the stage manager, glanced at the various props and scenery, feeling satisfied that all was in order for the next performance. He became aware of John walking towards him, carrying some small object in his hand. As he came closer the object came into focus. The stage manager's face hardened as he recognised the object ... A DEAD BUTTERFLY.

'Oh my god, where did you get that?' he asked.

'On the floor, outside No. 6.'

'That's trouble that is. That's big trouble.'

For the manager knew full well the implications of a dead butterfly. Taking the insect from John, he walked back into his office. After looking at it for a few seconds he laid it carefully on his table.

'Outside No. 6 you said?' he asked.

'Yes, that's right, just by the door.'

'Well something's going to happen now, and we aren't going to like it either.'

John prodded the inert form of the butterfly.

'Does this mean a death in the Theatre then?'

'Well, not necessarily, but quite possibly. What ever it means, it won't be pleasant. No son, this little devil means one thing, trouble, big trouble.'

'Or death', John answered.

'Yeah, as you say, or death.'

'We didn't get a live one on opening night either.'

'No we didn't, and with this blasted thing showing up we can expect some sort of bother.'

'Where do these live ones come from anyway?'

'God knows, you tell me. It's uncanny. If the pantomime is going to be a success we get a live butterfly flitting round the stage on opening night. It's really weird.'

'I reckon that it's the hot lights that wake them up.'

'Oh that's quite possible, it's been said before. But how do you explain the fact that it is mainly on pantomime opening night that one appears and seldom at any other winter show.'

'Yeah, strange that. Then there are the dead ones, where the hell do they come from?'

'Now you have asked something, just think about it. Did it fly there just to die on that spot so it would be found? Or did it just materialise? Or, was it put there, if so, by who or what?'

'Yeah, it's a right mystery.'

'Of course it's a mystery you twit, that's why it's a legend, no one can explain it. A previous owner believes that it is the spirit of the Theatre using butterflies to either bless or warn.'

'I wonder who this warning was for?'

'Did you say that you found it outside Bill Lynton's room? Because if that is where it was, it looks like the warning could be for him.'

At that moment Dennis, Bill Lynton's partner, returned from lunch. Overhearing Norman's remark, he asked him what he was talking about. Norman showed him the butterfly and said:

'We've just found this outside Bill's room.'

Dennis looked at the butterfly; he smiled at Norman and said:

'Oh yeah, death and destruction aye?'

'It could be', replied Norman in a serious tone.

'I'd better go and warn Bill of his impending doom by the dreaded butterfly.'

Dennis laughed, not taking it as seriously as Norman, who, looking very stern, said that he shouldn't laugh at butterfly warnings. Dennis said OK, he would treat it with a bit more respect; however, he was still chuckling when he left the office and headed for Bill's dressing room. Still smiling, Dennis opened the door of No. 6 and greeted Bill.

Bill Lynton was sat in his dressing room with his feet up on another chair; this was his usual practise around lunchtime because Bill liked to have a little snooze before the matinée performance. The door opened and in breezed Dennis. He called to Bill as he entered.

'Hey Bill, you'd better watch your step, there's a butterfly after you.'

As Bill didn't answer, Dennis, assuming he was asleep, walked up to him.

'Come on Bill wakey, wakey, do you know wha...!'

Dennis stopped talking as he neared Bill, who still sat with his feet up. Because Bill looked odd; he didn't look well, not well at all, something was wrong. Now thoroughly alarmed Dennis called for Norman, who came running.

'What's up?'

'There's summat wrong with Bill.'

Norman rushed into the room and shook Bill's shoulder.

'Bill, Bill are you OK?"

With that, Bill's full weight suddenly fell against him.

'Oh christ, get a doctor quick', he shouted at Dennis.

Dennis, who had been watching horror struck, turned and ran out of the dressing room; as he ran Norman called to him again.

'Hurry Dennis or it may be too late.'

Norman was right, it was already too late. Bill Lynton was sat with his feet up for the last time. The curtain had fallen on his last act.

Poor Bill was dead. A doctor arrived within ten minutes and confirmed what Norman had suspected when he first saw Bill.

The prophecy of the butterfly had come about again, as within two hours of the find of a dead butterfly a person in that vicinity had died. Later that night in the empty Theatre, Norman stood beneath the stage butterfly. Peering up into the gloom he could just make out the dim form of the winged guardian. Clutched in Norman's hand, was the dead counterpart of the symbol.

'Well you certainly told us that time, didn't you?' Norman said to the hanging butterfly.

He shuddered as an icy chill swept around him; it appeared to clamp around him like a living being. In the dim lighting the butterfly appeared to flex its wings.

Alarmed by this eerie effect, Norman shook himself to break the spell. The icy feeling vanished and the butterfly was quite still. Norman hurried back to his office that had a bright light burning. Back in the light again he composed himself, trying to rationalise what he had experienced.

Had he imagined it, for with Bill dying shortly after the butterfly was found, everybody had been on edge. No, he had certainly felt the icy chill, that was real enough, and he would swear that he saw the wings on the stage butterfly quiver. Feeling a strong compulsion to leave the Theatre, Norman placed the dead butterfly on his table, it was now very dry and stiff and its wings were beginning to crumble. Turning to his locker Norman gathered his belongings and left the office, turning off the light as he did so. He had taken only two steps when he thought it might be prudent to keep the dead creature as proof of the day's happenings. He retraced his steps and switched back on the light.

He froze at the doorway and a trickle of fear crawled up his back. The table was bare; the butterfly was no longer there. Maybe a draught had blown it off the table. Norman had a quick look, but there was nothing to be seen. By now the feeling of something ominous was so strong that Norman had had enough. He couldn't stay there a second longer, so switching off the light he departed rather promptly.

As he crossed the stage beneath the butterfly, Norman heard a strange sound; it was a gentle swishing sound. It wasn't until he got home that he rationalised what he had heard. It would have been the sound the flapping wings of a butterfly would make if it had a twelve-foot wingspan like the set piece hanging above the stage. Norman said later that the sound had really freaked him out. Apparently he heard three distinct soft whooshes.

The next morning Norman went straight to his office and, with the assistance of one of the stage crew, conducted a thorough search of the room. There was no trace of a butterfly, alive or dead, in that room. If anyone asks Norman about this event his main comment is about the electrifying atmosphere that surrounded the whole event; a tingling excitement that everyone that was involved felt, and the knowledge that the power of the butterfly was a very real and tangible force.

A MACABRE ACT

In a fraction of a second it had gone, vanished. Henry D. Adams had just poured out three glasses of wine on a small table. He replaced the bottle and picked up a glass of wine and the bottle suddenly disappeared, utterly and completely. He stood looking at the spot where the bottle had been; he did not appear perturbed at its sudden disappearance. Putting the glass back on the table, he took out a handkerchief and went as if to dust it. As the handkerchief brushed against the glasses they all vanished. Within five seconds the bottle and the three glasses had apparently ceased to exist. Henry still remained remarkably calm and turned away from the table. A sudden roar of noise swept towards him. His drawn, worried face changed momentarily as a tiny smile flickered and was gone. The noise of the applause from the crowded auditorium slowly died away at the completion of this last illusion of Henry D. Adams, 'Magician'.

Vince Hanley looked down from the heights of the flies. Thank goodness that's the last act and another show over, he thought. The pantomime season was quite pleasant but in 1952 it was hard work for the back stage crews like Vince. He checked all his

ropes, and satisfied that all was correct, he started down the stairs towards the stage door. He assisted the doorman with the queries and ensured that eventually everyone had left the Theatre, except himself and the doorman. As Henry Adams said goodnight the doorman said:

'Feeling any better Mr Adams?'

His reply was a tight-lipped nod.

'What's up with him?' asked Vince.

'Oh, I don't know, he's been acting strange all week, he was alright last week but he's been as miserable as sin this week, you know really low, depressed like.'

'Cash problems?'

'No, I don't think so, I'm not sure what's upset him but whatever it is it looks serious.'

'Well he certainly looks bad. Anyway I had better finish off the security checks.'

Vince picked up a torch and went on security patrol. He wasn't too keen on this part of the job ever since he had a ghostly encounter in the Theatre during the war.

The only lights in the Theatre now were the dim emergency lights, and the atmosphere in the dark, silent Theatre put all his senses on full alert. Vince made his way to the top of the Theatre and tried to remember to pick up a screwdriver he had left up there; if he didn't it would surely vanish, and not through any ghostly activity either. After checking the flies he then did a sweeping search down checking all doors, rooms and toilets.

Approaching dressing room No. 6 he felt his pulse rate increasing, No. 6 had an unsavoury reputation; a girl had been nearly burnt alive in there and someone had died in it. There was a malevolent atmosphere and sudden drops in temperature. He always felt uneasy in its vicinity.

He suddenly had a thought; of course, that's why Adams was so miserable, he had been allocated dressing room No. 6. That would account for his swings of mood. He comes here all normal, and after a couple of weeks sitting in this accursed room it's beginning to affect him.

Vince thought that he had found the answer to the misery of Adams. The door of No. 6 came into view. He stopped dead in his tracks and an icy prickle swept over him. The door of dressing room 6 was open. Vince knew that Adams, being a stage magician, was very security conscious about his tricks; he always kept the door locked and made sure that, apart from Vince, he had the only other key. The props were secret to him and no one, but no one, was allowed to see or examine the contents of his dressing room. So why was the door open? Either someone was trying to steal his secrets or Adams had returned to the Theatre after leaving and entered his room again, but why?

Vince slowly and very quietly crept up to the door, he listened intently, there was no sound, and all was still and quiet. As the door was slightly open he could see that it was dim and murky in there, no light had been turned on. With trepidation he pushed the door wide open and in a stern voice called out:

'Right, what you doing in there, come on out.'

There was no reply, the room was silent and empty, and so gingerly he went in the room to check that all was in order. He shone his torch round the room revealing the various props and paraphernalia used for the magical act, all appeared secure, and nothing seemed to have been tampered with. Vince still felt very uneasy and was conscious of the room's malevolence; he shuddered as he turned to leave.

Suddenly, a fluttering noise sounded in his ear and he spun quickly round as a soft fluttering insect flew straight into his face, startling him. The insect spiralled away from him and he breathed a sigh of relief as he saw that it was only a tortoiseshell butterfly!

It had appeared from nowhere and it now danced around the ceiling as if trying to find a way through it. Well, that's a good sign, thought Vince. There hadn't been a sighting of a live butterfly at this pantomime yet, so although things hadn't gone too badly without it, he was pleased to see a real live one in the Theatre; now all should be well. The fear he had felt before evaporated and carefully closing and locking the door he went down towards the stage, checking the rest of the area.

As he reached the stage proper he realised that he had still left his screwdriver way up at the top of the flies; ah well, he thought and proceeded to go back up the stairs. He retrieved his screwdriver and once more made his way down again. As he approached the vicinity of dressing room six he felt the usual apprehension but not the fear he had felt earlier. As he passed by he couldn't resist another look at the door he had carefully closed earlier. The hairs on his neck and arms suddenly bristled and fear swept over him again because once more the door of number six was half open. Vince knew full well that he had locked it not more than five minutes ago. The darkness behind the semi open door looked more ominous than before and once more he felt his skin crawl with fear. Something was wrong, very wrong. He could sense it, it was in the air, it was in the walls, it saturated the atmosphere, and it came from the darkness behind the door. There was something bad in there, he knew it.

He knew he would have to check the room out even though every nerve in his body wanted him to run, but his duty was to make sure all was well in the room. His mind said no, but his body was actually going to the door which he didn't want to do. Some force seemed to be making him go where he didn't wish to. The door swung further open as he gave it a push. He shone his torch around the brightly coloured boxes and shining silks and all was just the same as before. Nothing had been touched and no one was in the room. In the light of his torch the room lost its terror and looked almost cheerful. After swinging round the torch and seeing nothing amiss he felt a little more relaxed. Then it came again; a wave of prickly cold suddenly enveloped him. The sense of foreboding returned, the shadows once more seemed to hide something ominous, and once more there was the urge to get out. Then his torch flickered and went out, plunging the room into darkness, the only light being the emergency light in the corridor. Then he heard a strange creaking sound as if something heavy was swinging slowly on a rope. He then noticed a shadow projected by the emergency light that he could not have seen with the torch on. It was a strange shadow and it was something above him. His eyes followed the shadow to the ceiling where a small movement could be seen. He felt numbness spread through him as he saw it!

There was one, just one, a solitary single strand. It hung from the ceiling covered in dust. It looked like a piece of dirty wool. Even in the best-kept rooms you find them; the long, ropey strands left by a spider as it crawls along looking for its prey that then collect dust. This one hung straight down, it didn't curl or twist as they do in the slightest draught; this one hung straight because it had a weight on the end of it. The weight was a dead butterfly.

The end of the spider's dust web was coiled round the head of the unfortunate creature. It hung motionless except for the gentle swinging round and round which

had caught Vince's eye. Its wings were folded and its legs drawn up; the butterfly was dead. Its shadow, enlarged and distorted by the external light, duplicated its pirouette of death. It reminded him of the pictures of highwaymen hung on a gibbet, for they looked like black butterflies with their long winglike cloaks. Although this macabre symbol sent a shudder of horror through him, he knew he couldn't leave it there for Henry to find, as he was low enough as it was. If Henry found this object in his room, that would put the lid on it. Reaching up, Vince pulled the tiny corpse from its lethal noose and hurried from the room. He decided to keep this find to himself, if word of this got out it would upset everybody, especially in the strange circumstances of its death. Leaving the room he once more locked it and, holding the dead butterfly gently in his hand, he made his way to the stage door. The stage doorman looked up at him as he entered.

'Hell, what's up with you? You look like you've seen a ghost.'

'Maybe I have, I'm not sure'

Vince then handed the torch over to him. As he did so, it flashed back to life its beam, bright and strong, straight into the doorman's eyes.

'Hey, what you do that for?' asked the doorman.

Vince told him that the torch had mysteriously failed upstairs and was still switched on for some reason; as he passed it over it had come back to life. They both thought this was odd as it was a new torch with new batteries. After switching it on and off a few times, banging and shaking it, it was obvious that there was nothing wrong with the torch.

Vince didn't mention the butterfly; he thought the best thing to do was to see the stage manager in the morning and let him deal with it.

Returning to work the next day, Vince made sure that everything he had to work with was safe and secure; he was not going to take any chances, especially carrying a dead butterfly. Then hurrying down to the offices he knocked on the stage manager's door, as he had decided to tell the manager that he ought to tighten up on safety and security because of the omen he was about to show him. However, the manager had a short temper first thing in the morning and when Vince knocked on his door he was greeted by:

'Come in, what the hell do you want?' As Vince struggled to find the right words, the 'phone rang. The manager interrupted him.

'Hang on, hang on', and spoke into the 'phone. 'Yes, what? Who? He's what? Good god are you sure? I'll be damned, thanks, yes I will, yes thanks for letting me know.'

His face had gone white and he looked deathly serious, he replaced the receiver slowly. Looking strange he turned to Vince and spoke in a voice that was suddenly very low.

'Good God! Vince, that was the police, they have been called to Adams hotel as they were worried about him, he didn't respond to any calls and they've just found him – in his room – he's dead – HE'S HUNG HIMSELF!'

'I thought he might have done,' said Vince.

'What! What do you mean you thought he might?'

'Oh nothing, nothing just forget it.'

Vince turned and left the office, he walked slowly away, deep in thought. As he passed a rubbish bin, he stopped and crumpled something in his hand and dropped it in. It fell among the rubbish, a soft crumpled object; it blended into its surroundings. No one would ever notice it, it was only a smashed up, dead insect of no particular significance.

Just a common or garden tortoiseshell butterfly!

THE BUTTERFLY'S REVENGE

In the eighteenth century at the time of Richard (Beau) Nash, Bath was a gambling city. Bath was then the Monte Casino of Europe.

Richard, or Beau as he was known, apart from being the self installed King of Bath and the master of etiquette, also made some of his living from gambling and income from the numerous gaming tables.

Today the house of Richard Beau Nash still stands but now it incorporates two buildings, the Garrick's Head public house and the Theatre Royal Bath which is adjacent to it.

During the time of Beau Nash's stay, lots of traumatic events took place as people won fortunes and lost fortunes overnight which might account for some of the paranormal events which are now shared by both buildings.

There is an extraordinary tale relating to the Theatre Royal, which has a strong gambling theme. This remarkable story again involves the butterfly.

One Saturday, one of the backstage crew who was a keen gambler decided to wager on a six-horse accumulator bet. After carefully picking out six horses he placed a large bet on the result, and if this wager came off he stood to win a substantial amount of money. After placing the bet he suddenly had an idea. Knowing the power of the butterfly he went into the Theatre and made his way up into the flies until he was quite close to the hanging set piece butterfly. He held out his betting slip to the creature and said:

'Right, butterfly, I know you have all this power, well now is the time to prove it, here look, see, six horses, see. Now butterfly, all you have to do is bless my bet and make these six horses win, that shouldn't be difficult with all your powers, should it? I'm counting on you. You are, after all, the Winged Guardian of the Theatre and all in it, and as I am part of the Theatre, so you have to look after me, right!'

He leaned over and, kissing his fingers, placed them on the butterfly.

(At this time it was possible to reach and touch the butterfly, it has since been moved to make it hard to get at.)

He then awaited the results, confident that with the butterfly's power and control over luck and fortune, he would soon be a rich man.

Then it came time for the first race, he listened intently to his portable radio. As heard the commentary, his excitement grew and he yelled:

'Yes', and punched the air.

The first horse had won; he was on his way. As each race result came in he grew more and more excited, for every horse he had picked was a winner. Eventually he had five winners and only one to go.

Tingling with anticipation, he listened to the last race; first he was excited, then worried, and then excited again, as his horse (which will be referred to as 'A') and another ('B') were neck and neck and kept swapping first position.

The commentator's voice rose higher and higher with excitement. First one was in front, then it changed and the other was in front, and then he couldn't distinguish one from the other. They were into the last furlong, they were coming up to the post, and the commentator was screaming.

'It's (A) no.'

'It's (B) yes, no it's (A), oh, I really can't say. They are past the post together, it's a photo finish. I think it was (A) but we will have to wait now for the photo.'

The poor gambler was beside himself with tension, he gripped his radio so tight the plastic was creaking. Although the volume on his radio was turned up high, he had it pressed to his ear in case he missed anything.

The reason he was so uptight was the fact that he had won five races and, after each horse, won all the winnings and the stake money went on the next horse, so with five winners he now had a potential fortune within his grasp.

If this last horse won he would be able to retire on a very large sum of money, if it lost he may have a bit of beer money but that was it. He now had to sweat it out.

'God, how long does it take them to develop a blasted photo?' he asked no one in particular.

The radio crackled and the commentator's voice rang: 'Ah yes, they are putting up the result and it's...'

As the winner was announced the gambler froze, his knuckles turned white as he squeezed the radio; it was a wonder it didn't break into tiny pieces. (B) had won and his horse (A) was second. A look of stunned horror spread across his face.

He couldn't believe it. It had lost! His bet was down, he hadn't won. He had lost on the last horse. A wave of disappointment swept over him. How could fate be so cruel? Race after race had come up, five in all, and at each win his hopes and expectations grew to an unbearable anticipation and now the sixth, the very last one, was there at the post, it was there at the front, but had lost by a tiny fraction.

How could it have lost? He stood there stunned his face ashen, he really thought he had it made it this time, every horse had just sailed in and hadn't the butterfly blessed his bet? His disappointment gradually turned to anger.

That bloody butterfly had done it on purpose. It had led him to believe that he was going to win, and what does it do? It smashes his hopes at the last moment. Right, if that's the way it is, so be it.

All his pent up frustration, disappointment and rage at losing had now found something to blame for his ill-fortune; the butterfly.

With a burning anger he strode back to the stage area and cursing loudly made his way to the flies. In the stage area his colleagues stood looking aghast as he stormed his way towards the butterfly, letting forth a string of abuse directed at the creature.

This was unheard of; how could anyone dare to insult this, the almost sacred symbol of the Theatre? He then committed what amounted to sacrilege in the Theatre. Leaning over he swung his fist and actually punched the butterfly. His companions watched horrified as the winged guardian swung back and forth with the impact of the blow. The still fuming gambler carried on cursing and called the butterfly unrepeatable names then, with one last shout of a cursing insult, he left and strode angrily out of the Theatre, leaving behind a lot of worried men.

They all knew deep inside themselves that this act could only lead to disaster. There would be retribution of some sort that was for sure. They knew that the butterfly would avenge itself in some form or other. No one in their right mind would throw down the gauntlet to the butterfly. They were proved right that very same night.

The last show of this production came to an end and the curtain fell after the last curtain call. The cast scurried back to their dressing rooms and changed, ready to travel to the next venue for their show. As soon as it was convenient the stage manager came on stage and began to detail the backstage crews on dismantling the set.

Tonight was Saturday night, known as 'Get out' night, as this show had to 'get out' before the next show could 'get in'. This entailed removing all the scenery and packing it up into the removal van, which was no easy task. Everything had to be done in a planned sequence to prevent chaos.

'Right lads, let's have you,' shouted the stage manager. 'We should have this lot out in a couple of hours.'

The crew went swiftly into action, expertly dismantling the various props and lighting. As they worked they cast the occasional glance up at the butterfly. Because tonight it didn't appear friendly at all; there appeared to be a malevolent atmosphere surrounding it. The gambler was quite unperturbed by their anxiety. In fact, he displayed a marked contempt for the supposed powers of this ridiculous insect.

'Right let's have the wardrobe next,' cried the manager. The crew assembled around the huge heavy wardrobe.

'Now careful, this bloody thing's heavy.'

There was no need to warn them, the crew were fully aware that they were working under the butterfly, and no one was going to risk a slipped disc or rupture. For they were all expecting something drastic to happen, and didn't wish to be involved in any accident that might occur.

'Come on get your backs into it,' he shouted. 'Now then, tilt it over and lower it down.' Inch by inch the heavy wardrobe tilted as the men took the strain and began very carefully to lower it down.

'Slowly lads, slowly, easy does it,' coaxed the Manager.

Expertly, the crew continued to lower the heavy piece of furniture to the stage.

On the cue sheet relating to the removal of the scenery was an item delegated to the gambler, the instruction had been to remove a heavy plastic moulding prior to moving the wardrobe. As the gambler was still agitated about the day's events he had forgotten to do this; it was still up there on top of the wardrobe. The wardrobe tilted farther down and then it happened.

The heavy moulding on the top of the wardrobe suddenly slid and fell. It crashed down with tremendous force. Stood right beneath it, was the gambler. With a sickening thud it struck a terrible blow on the back of the neck of the luckless man. The impact slammed him to the stage with a loud bang. Then all was deathly quiet.

His companions stared in horror at his now inert form. He lay like a broken doll, his head twisted to one side, his face was a sickly blue-grey and there was no sign of life; this was to be expected, as his neck was broken.

Above him in the flies, the ornate butterfly swayed gently. The crew looked from the body to the butterfly; they all looked at each other, nothing was said but they all knew what each of them was thinking.

Postscript

The unlucky gambler's luck did not all run out; he survived the accident and did not die even with a broken neck; but of course, he suffered a lot of pain and was incapacitated for a long while.

The butterfly had taken its revenge.

The Garrick's Head public house.

THINGS THAT GO BUMP

This act is of a miscellaneous nature, the stories ranging from interesting to horrific, and in Paul and Andy Williams's (Stage Doorman) cases almost vampiric; you'll find that some hauntings appear to have no aim while others appear to have a definite purpose. While compiling this book I was overwhelmed by stories that poured in from a variety of sources. This once again confirmed the fact that the Theatre Royal is not so much haunted as infested with ghostly activity.

There are of course many haunted Theatres; the Old Vic in London has its ghost in the form of an anguished Lady. A good-looking male ghost haunts the stage of the New Theatre, St Martin's Lane, and a dancing phantom girl together with an old lady haunt the Grampian. Strangely enough another Theatre Royal had the reputation of being the most haunted Theatre in Britain; I'm not sure if it is still used as a Theatre but it stands in Margate.

After wading through the mass of information that has surfaced since writing this work, I strongly dispute any other Theatre's claim to being the most haunted.

I believe there are two reasons why this gem of a Theatre has such a predominance of the supernormal. Most Theatres pick up some form of psychic phenomena, which may be due to the high emotions generated by actors and the stress caused by their desire to get it right. The second reason is the unique position of the Theatre itself.

The whole surrounding area abounds with spirits and ghosts. The Theatre is sandwiched between two houses, both of which were the abode of Richard (Beau) Nash. The Garrick's Head was his original house, and part of this is built into the Theatre. Poltergeist activity plagues the Garricks, which also has two principle ghosts, one of them being the Theatre's own 'Grey Lady', plus a man in a red wig.

Popjoy's Restaurant lies on the other side of the Theatre and was the second home of Beau Nash; it is named after Juliana Popjoy who was Beau's last mistress before he died there in 1761.

When Beau Nash died she went away to a village where she became a recluse and eventually died as a wizened old woman dressed in rags. In 1975 a patron to Popjoy's ordered a very expensive and unusual meal and took his apéritif up into the large lounge to await his meal. After five minutes or so, the staff were horrified to hear a scream of fear from upstairs, followed by the sound of breaking glass as he tore down the stairs out the door and into his car. Revving loudly, he accelerated swiftly away from the restaurant.

It was a while before the hotel where he was staying revealed his story. He had rushed back to the hotel, blurted out his story and then left Bath forever never to return.

This is his story.

I went to that place you told me, Popjoy's; I ordered a meal and took my drink up to that funny old-fashioned lounge upstairs. It was empty so I walked to the far end to sit on a green settee.

As I turned to sit, I saw there, in the centre of the room, a lady of standing, an aristocrat of a bygone age; she had jewellery and a long beautiful dress.

She was not there when I went in and I was surprised to see her there. To be polite I smiled at her; she did not smile back.

I suddenly felt very uneasy and embarrassed, so looking at my drink I sat down. When I looked up, she was sitting right next to me.

I did not see her cross the floor and she didn't have time to do so anyway.

Shocked, I turned to look at her, but as I turned she turned towards me and as she did she began to shimmer, went all hazy and then changed from a lady of standing into a hideous old witch dressed in rags. Then she just vanished; just like that, vanished, gone, and that's when I vanished out of there. You can stuff Bath; you'll never see me again.

All around the Theatre are buildings that have their own individual ghosts and happenings.

With all the wild goings on that took place in the eighteenth century, it would appear that Beau Nash left more than etiquette in his wake.

The city of York claims to be the most haunted city in the UK; I don't agree. Like Bath they have a ghost walk, but they rely on dressed up guides and assistants jumping out of doorways to create their atmosphere; however, if you are in Bath and would like to know more about the ghosts in this area, I strongly recommend that you join the 'Ghost Walks of Bath', which starts from the Garrick's Head at 8 p.m. on Thursday, Friday and Saturday nights. There are no gimmicks or staged events on this walk as the ghosts and atmosphere are very real. A guide will conduct you on a pleasant and interesting tour, relating the ghostly tales that surround some of the locations on the route. Visitors

Enter the twilight zone

THERE was something spooky going on.

It was a cold, misty October night, and I had arranged to meet my guide for the evening in the old Garricks Head pub, next to the Theatre Royal, in the centre of Bath.

The Abbey bells struck eight as I took a deep breath, pushed open the heavy door, and walked into the crowded bar. Almost before it slammed shut behind me, a smiling man emerged from the smoke, hand outstretched, stating: "Good evening, Mr Titley."

How did he know it was me? We shook hands, and I apologised for my rather cold, clammy palms, nervous facial twitch and embarrassing stomach problem. I'm not normally like this, you understand, it's only when I'm bracing myself to meet the undead . . .

He laughed. A long, cackling laugh. The sort you're more used to from the baddies on Scooby Doo. But at least on Scooby Doo, the ghouls are really just people dressed up in sheets, trying to scare off the meddling kids and stop them from discovering the treasure.

The Ghost Walk around Bath was different. It was meant to be full of real zombies, creatures from beyond the grave with hollow, staring eyes, stumbling around in a trance. I ought to be used to that, I told myself, it's just like the office.

"Shall we begin?" My guide's smile broadened into a grin, and I was relieved to see he had a full set of teeth. Malcolm—a little more reassuring than Count Van Heidelburg or Freddy.

The spirits are restless . . . as Hallowe'en draws near, CHRIS TITLEY takes a fresh look at some old haunts

We were, it transpired, sitting in one of the most haunted places in the city. There were more spirits floating around the air in The Garricks Head than there were behind the bar attached to optics.

Beware if you smell the heady scent of jasmine in the Garricks, Malcolm said. It does not mean the landlady has gone a bit over the top with the air freshener, it means the Grey Lady is going to appear.

She has been a regular at the pub ever since she fell—or was pushed—from an upstairs window to her death.

Her boyfriend fared little better. After being caught in bed with the Grey Lady by her husband, he was fatally injured in the resulting duel and carried upstairs to die.

He now makes his presence felt by occasionally staining the ceiling red with his blood. After a few days the stain vanishes.

Most of the sightings of these apparitions would more than likely be by patrons of the pub, probably towards closing time.

But sceptics should think again: apparently, a team of scientists has confirmed the ceiling stain was indeed human blood, with no apparent cause.

And Dame Anna Neagle saw the Grey Lady walk across the stage of the Theatre Royal during a performance one night. She never returned to the theatre again.

Normally, I'm not one to leave a pub in

a hurry, but that night I was quite happy to move on. Yet worse was to come.

As we were taken around the moonlit streets, we learnt of the shadowy figure that stalks Trim Street; Sylvia the Bride of Death, who hanged herself with her girdle in Queen's Square; the Man in the Black Hat.

Not the sort of people you would choose as babysitters. Malcolm said they had all been seen on previous Ghost Walks, but they stood in a line. I tried to assure him I didn't really mind.

Malcolm, a former stage hypnotist, was the perfect guide. He would set the scene in the best spine-chilling fashion, until you were gripped with fear—or, more often, by the person standing next to you.

Then, just as you thought, or, even worse, start trying to whistle a happy tune, he would relieve the tension with a joke.

It was all serious—deadly serious—when we got to the Gravel Walk, near the Royal Victoria park, however. By the time he had recounted his tales of restless spirits slain on the duelling ground nearby called The Dell, everyone swore the temperature had dropped a good few degrees.

It is all great fun, and tremendous value, with more bumps in the night than a ride on the dodgems. Anyone who enjoys a good scary yarn will be in heaven on the Ghost Walk. And they won't be alone . . .

☐ For details of the Ghost Walk, pick up a leaflet from the Garricks Head pub, St John's Close, Bath.

☐ For the Mayor's Guide walks, see the Listings Guide in Thursday's Evening Chronicle.

Write up of Ghost Walk.

from all over the world have been on this walk and, judging by their correspondence, thoroughly enjoy it. It is nearly two hours of thought provoking entertainment. You may have your first psychic experience here.

As the surrounding area is crawling with the unknown and Theatres are prone to them it's hardly surprising that the Theatre Royal has such a rich abundance of ghouls and ghosts and things that go bump. Well, if you are ready to continue with the show. You have your ticket; you have your popcorn and hopefully a drink of some kind. For, believe you me, it is best to be fortified with spirits in the glass before meeting the spirits that abound around us. Ok then, let's go...

THE DOORMAN

It was a hot summer's day and an actor hurried through the foyer into the Theatre Royal, mopping his brow with a handkerchief.

'Phew, its hot today Derek, how the hell does that poor bloke stand out there with all those hot clothes on?' he said.

'What you talking about?' asked Derek Lewis, the bar manager.

'That bloke out there all togged up in old fashioned clothes', replied the actor, indicating the foyer which is situated just outside the Lower Circle bar.

'What! Is he there now?' yelled Derek.

'Yes, I've just passed him.'

'Right, I'll have him this time', shouted Derek, and rushed out of the bar into the foyer, but it was empty.

'Well, he's damn well gone now', said Derek, returning to the bar.

'Hell! He must have shifted, and I just this second passed him. He looked as if he was in a trance anyway; he just stared in front of him and never even turned his head when I passed him.'

Over the weeks a pattern had emerged. Actresses, actors, dancers, in fact any member of the cast of the current show would casually remark about this odd chap stood in the foyer dressed in a tricorn hat, a longtailed jacket with big brass buttons and a doublet and hose; a real blast from the past.

Derek had got fed up with people saying they had just seen him when no one else had. Sometimes out of curiosity he would go out and, seeing nothing, would tell the witness they were seeing things.

As the reports kept coming in over quite a period of time from different people, with no contact with each other, he began to wonder what it was all about.

The only explanation he could come up with was that someone was dressing up as a joke.

But it then emerged that no one on the Theatre Royal staff, both front of house and back stage had ever seen him; not even the box office staff that work in the foyer right next to where he is usually reported to stand. The only people to see this mystery man would be attached to, or playing in, a live show.

The sightings were not consistent; no one would see the man for a time and then either one or two cast members would see him again.

Who on earth was this fellow, and why did he keep standing there only to disappear after being seen? No one knew, but it was certainly very strange.

Derek decided that he get to the bottom of it and investigated every sighting but to no avail. He just did not know what to make of it. It was suggested to him that it was a ghost, which Derek promptly dismissed.

So he was quite angry that he hadn't caught this troublemaker, even though he had jumped into the foyer two seconds after the figure had been reported.

A few weeks after this episode, Derek was a witness to a witness, so to speak.

It was mid afternoon on a pleasant summer's day, there was no matinée and Derek, having finished stocking the bar, was stood in the doorway of the lower circle bar with a full view of the foyer, when two people laughing and joking pushed open the Theatre's door and entered the foyer.

They were a young female member of the cast with a Theatre Royal stage technician who she had befriended.

They had just had lunch in the Garrick's Head and, in a happy mood, they had returned to the Theatre. As they neared Derek the girl remarked to her companion:

'What's he stood there for?'

The stage technician turned round puzzled because he hadn't seen anybody; as far as he was concerned the foyer was empty, apart from Derek who was in front of them.

'What's who stood where for?' he asked, as she had vaguely waved her arm towards an empty part of the foyer.

'That fellow.'

'What are you talking about, there's no one there,' he said.

The girl, still smiling, turned and indicated an empty space in the foyer, and said:

'Why, him of course ... Oh no, my god!'

With that the girl gasped, put her hands to her face and backed away, repeating over and over, 'Oh, my god no, god, no, god.'

The technician and Derek had seen absolutely nothing, but the girl was in a very genuine distressed state. Seeing that she was on the point of collapse, both Derek and her friend helped her into the bar and sat her down on a seat

'Didn't you see it?' she kept repeating over and over. 'God, he just disappeared, how could he do that?'

She was trembling violently and Derek got her a brandy from the bar. After a while she calmed down and, although still trembling and shaken, she told her story.

As they entered the foyer, she had seen a man dressed in old-fashioned clothes. He had a tricorn hat, a long velvety coat that swept round to the back, he wore knee breeches and buckled shoes and also had on a red wig. (Note: A man in a red wig also haunts the Garrick's Head.)

He hadn't moved when she had entered. He had just stared straight ahead. When she had passed by him and the technician had queried what she said she had seen, she had turned round only to see this man suddenly fade away in front of her and vanish.

So there was the answer to part of the mystery. The phantom doorman was just that, a phantom, or ghost. Whose ghost it is, no one knows. The odd thing about this fellow is that he only appears to members of the cast. He has never been seen by anyone on the staff.

Knowing the Theatre and its staff, it's pretty certain that he once worked there as a doorman in days gone by, and like most of the staff, whether they be dead or alive, he can't resist just popping in.

This event was in the late 1970s and things have changed physically in the foyer since then.

Today, as you enter the Theatre, the Box Office is a counter on your left-hand side, but in those days the Box Office was facing you and sat in the centre back of the foyer, just like the old Bijou cinemas.

When the Theatre re-opened in 1982 after extensive renovations the old Box Office had been removed and the left-hand counter installed.

Since that time there has been no reported sighting of the Phantom Doorman.

THE THEATRE SPEAKS

The Theatre was dark and empty; soft whispers appeared to emanate from the shadows. The empty seats in the deserted auditorium seemed to be staring at non-existent images on the stage. All was quiet and all was still, except for one small movement in this expanse of solitude. Footsteps sounded, slow and regular as they echoed up the stairs leading to the Gallery. They were lonely footsteps. Their creator was very conscious of the silence and the absence of a fellow creature.

Andy Williams, the Stage Doorman, cursed to himself; he should have been home by now along with everyone else, if he had only remembered to secure the windows in the Gallery.

Andy wasn't too keen to be alone that night, for the atmosphere was distinctly odd. Andy was quite used to walking through the empty dark Theatre. Most of the time it didn't bother him; however, on occasions he had experienced apprehension and fear, and a feeling that something was in there with him.

He could feel it again tonight, only this time it was stronger. There was something about the atmosphere that made him want to run outside, and if he had closed those rotten Gallery windows, he would by now be well away from this frightening feeling that surrounded him.

The stairs didn't help either; he was climbing the stone stairs from Beaufort Square, and had already had nightmares about them. The stairs went round and round; like climbing a square lighthouse. Four steps up and turn, four and turn, and at each turn Andy felt as if something was waiting for him, something unpleasant, something dreadful.

Would these stairs never end; they seemed to go on forever. Andy felt that one of these days he would just keep on walking and finish up among the stars. As Andy climbed warily up these foreboding steps he felt another strange feeling that he had had before.

He sensed that the Theatre itself was a living being and was conscious of him being there. Or maybe it was the butterfly watching him. Well, he hadn't upset the butterfly that was for sure; Andy treated the image of the butterfly with a marked respect, he had seen what it could do if slighted.

No, Andy felt as if he was a microbe crawling inside the body of the living Theatre. At last he reached the door to the Gallery.

Hurrying through, he went straight to the windows and slammed them shut, the sound echoing through the yawning cavern of the empty gallery. Andy didn't feel too easy in the Gallery either, for it was reputed to have two ghosts haunting it; one being The Grey Lady who was everywhere in the Theatre, and some say that a previous female owner also haunts the area. Unlike The Grey Lady she doesn't trail the scent of jasmine; her choice of perfume is sandalwood. There is also the smell of parma violets when she is around; they must have been her favourite sweet. Although he had never seen her he had at times smelt her perfume and sweet breath.

A feeling of foreboding flooded his senses and the atmosphere now felt more ominous. However, no matter how nervous he felt Andy was also extremely conscientious; his job was security so as he was up in the Gallery, he would check that all was well in the rest of the Theatre.

From the Gallery, most of the auditorium could be observed, so Andy descended to the centre of the Gallery seats and, from this vantage point, surveyed the rest of the Theatre for signs of fire. He shuddered as he caught sight of The Grey Lady's box; thank goodness it was empty, it looked like a spooky black cavern.

The silence was terrible; a strong ringing started in his ears. The shadows seemed to be alive as if full of writhing shapes. A horrible prickling feeling swept over him. Something was wrong, very wrong. Something knew he was there and Andy felt desperately small and defenceless. He turned to leave, or at least, he tried to turn to leave. However, at the moment he decided to go, a cold damp feeling seemed to wrap itself around him. He wanted to move but found he couldn't. He felt a sense of evil around him and a power much stronger than himself. Fear pulsed through him in waves as he struggled to free himself from the strange numbness that held him captive. His view of the Theatre became distorted, the shadows moved and danced about. The silence became louder; the ringing in his ears became a high pitched whine. He felt as if he was surrounded by thousands of malevolent midges that were not of earthly origin. Whispering sounds, like far off voices, penetrated his consciousness.

The whole atmosphere of the Theatre became charged with unseen life. There was something dreadful coming for him, not one thing which he had at first sensed, but thousands. The Theatre seemed to be filled with minute darting dots of horror.

They were closing in on him, causing a terrible claustrophobic feeling. The ringing in his ears now sounded like a shrill scream. His senses began reeling as the unreality of the situation became more than he could stand.

The hideous particles continued to close in on him. Then, to his horror, he saw they were forming into a cloud; an entity was being formed in front of him, all the particles were uniting into a spiral of smoke or mist. As he watched spellbound he saw a shape forming; it was like the shape of a carrot, big and bold at the top but tapering down to a small tail; whatever it was it was something he didn't want to see.

The top began to sway towards him and a physical fear crawled like pins and needles over him. He didn't want to be there and didn't want to know what was forming in front of him.

His mind flashed a cry for help. In his mind's eye he saw the image of the butterfly; he was a friend of the Theatre and respected the butterfly's power, and mentally called to it for help. Something answered.

Right above his head a tremendous bang rang out, the concussion slammed through the building, and shock waves raced through Andy's body. It was only by a great effort of will that he stopped from disgracing himself.

The ringing in his ears ceased, and then there was a BANG – another stunning crack echoed through the Theatre. Andy's vision cleared and the icy clamp vanished. A third almighty bang rang out and Andy snapped out of his trancelike condition and found himself running down the stairs as he had never run before.

He flew through the outer door and, slamming it shut, he locked it. He ran from the Theatre for several yards, then stopped and leaned against a wall as a feeling of weakness come over him. He realised that he was breathing very hard and very fast but couldn't seem to get enough air. Slowly he got his body under control and eventually

made his way home, making sure he was always in the glare of the streetlights. The shadows frightened him.

Back in his room he sat and tried to reason out what had happened to him.

However, when dawn broke, he was still sitting trying to think it out. On the two attempts he made to try and sleep the full horror of his experience flooded back and jolted him awake.

Since this occurrence he has come up with his own theories as to what took place that night.

He believes that all the evil or bad thoughts and acts that have occurred in the building, through the mental energy of actors/actresses psyching themselves up to play their characters from times past, had, by some psychic freak, become manifest and were forming their own entity, a combination of everything. Now he was alone it was trying to express itself through him.

What were the bangs? To be fair, these could have been a natural contraction or expansion of the Theatre's structure; however, Andy believes the power of the butterfly or the spirit of the Theatre made them. If you had an association with the Theatre for a length of time you would be inclined to believe this too. Whichever force was responsible, it shocked Andy out of his trance and dissipated the swarms of frightful beings, whatever they were. Andy believes that if he hadn't snapped out of the hold on him he would have been found there in the morning, raving mad or very very dead.

The strange thing is that Andy is no longer afraid to walk the empty Theatre, and is quite happy to wander round when all is quiet and dark. He no longer feels the presence of something being with him, and believes that the butterfly force that came to his rescue also destroyed or banished the latent malevolent forms away from Andy forever.

THE SHADOW

Harmonious chords of organ music flowed through the Theatre. The rise and fall of the music seeped through the whole building. It wasn't the usual music that you associate with an organ. It had a strong beat and a pleasant rhythm, more the type of music you would hear in a disco. Eventually the music came to an end and the echoes of the last notes faded into total silence because, apart from the lone organist, the Theatre was completely deserted and dark. No applause rippled out of the darkened auditorium that was lit only by emergency lighting.

Andy Williams, who had once suffered a frightful experience in the Theatre, was now quite happy to sit in the empty, dark building late at night playing the organ. He sat quite content and absorbed in his music. In spite of his previous experience he now felt safe and secure in the Theatre, for he knew that some force or power had a protective influence and could banish evil. He was pretty sure it was the butterfly, which at this moment now hung silently above his head. Whether it was the butterfly power that saved him, or whether the Theatre itself had a power of its own that it could activate against anything that threatened its friends, he didn't know. Whatever it was, Andy knew he could bask in its protection.

He had finished his security rounds, but was fascinated by the organ on stage. Being a musician, he was the lead guitarist and singer in the popular group 'The Decoys'; he had wondered how the tunes he had composed for the group would sound on an organ.

Although it was strictly forbidden, Andy thought this was an ideal time to try it out, as he was alone in the Theatre and it was way past midnight.

He plugged in the organ and after a few tentative notes he began to play a few tunes, varying the tempo to achieve the correct effect. As his confidence grew, he slowly increased the volume until the whole building echoed with strident notes of an organ playing rock. He thought what it would be like to play in front of a large appreciative audience. In his imagination, the auditorium filled with a worshipping audience. There was a mirror on the organ directly in front of him and he could see a reflection of the bare wall in the wings. He was halfway through a foot-tapping tune when he glanced in the mirror. He detected a movement reflected in the mirror.

Andy froze and felt that old familiar prickle crawl over his skin. Then it was gone. Nothing could be seen now so he turned quickly and looked behind him. Nothing! All was still and quiet.

He walked over to where he had seen the movement in the mirror. Nothing! There was no one or thing that could have moved. Must be my imagination, he thought, and going back to the organ resumed playing.

Suddenly in the mirror he saw a definite movement. A shadow slid across the reflected wall and stopped. Andy's fingers stopped their playing as he stared at the shadow. It was the shadow of a man but twice as large; the shadow's head was cocked to one side as if listening. Andy found his voice, although when he spoke it sounded very husky.

'Hello ... Who's there?'

There was no reply; the Theatre was deathly quiet.

Andy turned round – the shadow had gone. Strangely enough, Andy didn't feel frightened, but was extremely curious. Turning back to the mirror he stared at it for a few minutes, but nothing happened. With another glance behind him, Andy once more began to play.

The first few chords rang out and the black shadow reappeared in the mirror. Andy immediately spun round. No shadow – he flicked back to the mirror – there WAS a shadow in the mirror. Turning quickly round again, there was NO shadow, when he looked back again into the mirror the shadow had gone.

Andy thought, enough is enough, and, unplugging the organ he locked up, deciding to call it quits, then once more he saw a movement on the wall, this time without the aid of the mirror.

Again it was the shadow of a man, in what appeared to be a long cloak.

'Who's there?' Andy croaked; his voice wouldn't work properly.

The shadow then began to change shape from that of an outsized person to a distinct sharp edged triangle. It began to diminish and grew smaller and smaller until it was about two foot high; then it seemed to tilt to one side edge on like a 3D model, and dissolve into the wall.

Andy thought again, enough is enough. Although he wasn't panic stricken like the last event, he thought it prudent to depart at this stage.

Andy says that, apart from the goose bumps he felt, knowing that something unreal was happening, he didn't feel any fear. He sensed that whatever or whoever it was had a friendly aura, and had just come to hear the music. Andy laughs when he says that 'it must have been a 'with it' ghost for I was playing the music that our group 'The Decoys' play, and we are as modern as you can get. To attract a ghost proves one thing; our music is really out of this world!'

ANDY'S AFFIDAVIT

I approached Andy after his spooky encounters and asked if he would present me with an affidavit of his encounters. He agreed immediately, but when I went to collect it he also handed me a small poem, he said: Is this any good for you? When I read it I was a little surprised, because after all Andy's ghostly experiences one would have thought that he would have no affection whatsoever for the Theatre Royal Bath.

Just the contrary, in fact; Andy had really immersed himself in the atmosphere of the Theatre.

He told me that one night the week before he was all alone in the Theatre and he went on the stage about 1 o'clock in the morning.

All was silent, all was still. He stood on the empty stage and surveyed the empty auditorium. He felt calm and peaceful; there was none of the trauma that he had experienced in the Gallery, just a sense of calm and belonging.

As he stood there, a fragment of prose entered his consciousness and, as he stood there, words began to form in his mind. These formed into this gem of an item in the form of poetry. Please read and understand it; if you love the Theatre you will understand.

THE THEATRE by A. C. WILLIAMS

As I stood alone on the empty stage, the silence set in.
 The sound of music and laughter had now gone.
Replaced by deathly silence, only broken by the wind blowing against the cloth or
 rafter, or a creak in the auditorium.
My imagination seemed to expand in the emptiness of the Theatre, until the silence
 returned creating a sound of its own.
The Sound Of Silence.

1942

On the 26th April 1942 Vince, a firewatcher, walked slowly from the stage area to the stage door office. He felt alone and vulnerable and he sensed imminent danger. Vince now felt real fear; fear for the Theatre and fear for his own life. It was night-time and there was little light in the Theatre and outside was dark, as there were no streetlights. He carried a dim torch that only illuminated a small close area. A few minutes earlier he had heard a sound, a sound that sent a chill of fear through him. It was the rise and fall of the air raid siren, but conscious of his duties, he carried on to the stage door office. Vince went to the small window and looked out but it was too dark to see anything. Vince was looking up to the sky when it happened; he immediately felt fear tighten around him.

As Vince looked up the darkened night sky above, the Theatre Royal was suddenly illuminated with shimmering beautiful bright lights that hung in the sky like huge firework chandeliers. Their beauty hid a sinister purpose, a purpose of death and destruction.

An ominous throbbing sound could be heard in the sky above this cascading glitter. Then the cry of a banshee could be heard; at first it was a faint wail that became louder

and louder, until it became a scream, a scream which filled the mind and induced a fear of death.

It grew louder and louder until it became intolerable, then there came a stunning detonation and a huge sheet of orange flame whiplashed a hellish wind across Kingsmead Square which ripped off tiles and transformed windows into speeding needle-sharp shards. Thick dust, debris and broken glass whirled through the air and the concussion rocked the Theatre Royal.

The first whistling bomb of a very heavy air raid had landed. A few seconds later there was another, then another. The City of Bath was under attack.

Under the orders of Adolph Hitler, Bath was to be destroyed as it was part of English heritage.

The sky began to sparkle with pin-pricks of light as anti-aircraft shells burst in the air in an attempt to shoot down the Luftwaffe raiders. The raid intensified, as a hail of bombs crashed down destroying buildings, even whole streets and killing people. To add to the horror, low flying aircraft swept in and strafed the city. Machine gun bullets and cannon shells ripped through houses and riddled the vehicles of the civil defence vehicles. Then dive-bombers came swooping down and releasing their deadly cargo of destruction. Georgian and Victorian buildings disappeared forever in a hail of smoke, dust and shattered stone. Incendiary bombs showered down on shattered buildings, starting uncontrollable fires, burning priceless artefacts and leaving people trapped in the debris of what was once their homes. The Assembly room became a sheet of flame and was destroyed.

Vince lay on the floor and shielded his head as best he could, and as detonation after detonation rocked the Theatre, the floor seemed to heave up as some of the bombs fell quite close. Vince felt he was going to die, and with him would go this treasure, the Theatre Royal. All this beauty, all this atmosphere was going to be blown to bits by some stinking chemicals that would leave it a smoking pile of rubbish; a waste, a terrible waste.

These were the thoughts that ran through Vince's head as he waited for the bomb with his name on it. He took comfort in the fact that it was said that you never hear the bomb that gets you. That was until part of his mind rationalised that you can't ask a dead man if he heard it coming. Still the raid continued. Vince was conscious of the sounds around him. The whistle and shriek of the bombs that had whistles fixed in the fins to add to the terror, the staccato sound of machine guns, the howl of over revved engines as the dive bombers zoomed down and up again. Intermingled with the roar of explosions he heard ambulance bells, people shouting and screaming and the rumbling roars as buildings collapsed.

The peaceful City of Bath had become an inferno it was turning into a pile of smoking rubble. Bang! Bang! Bang! Three huge explosions rocked the Theatre as three bombs exploded close by. Then there was a lull. The bombs stopped, the dive-bombers droned away and all that could be heard was the hum of a high flying bomber that was circling round.

After about a minute Vince got up off the floor and brushed himself down; he would have to check the Theatre now, as that was his reason for being here, Vince was on duty as a firewatcher. He glanced at his watch; it was exactly three minutes past one.

A vivid blue flash lit up the window of the office; Vince ducked, but there was no explosion. He looked at the window and in the flickering light of the burning city

he could see a silhouette in the window, someone was looking in. He stared at the shadowed head trying to see who it was when another searing blue flash lit up the window. It illuminated the face and Vince recognised him immediately; it was his best friend. But what was he doing here? Vince knew for a fact that his friend was fire watching at the Francis Hotel that was about 500 metres away and he should not be away from his post.

His friend appeared agitated and was frantically mouthing something to Vince but no sound of a voice came to Vince's ears. The window was very small and only the head and part of his shoulder could be seen but it was obvious that he was trying to tell Vince something. It was difficult to see him properly as flickering shadows distorted his facial features, still partially lit by a strange blue glow. Vince began to walk towards the window at the same time indicating his friend to come in the stage door which is adjacent to the window. It also crossed Vince's mind as to what his friend could be stood on, as the window is about twelve feet above the pavement level. There was another silent blue flash and his friend raised an arm and pointed in the general direction of the hotel, then after he pointed to the sky he then pointed to himself, and then appeared to salute Vince.

There was a blinding white flash and a stunning crack as another bomb fell nearby; instinct made Vince dive for the floor. As he picked himself up again he saw the window was empty, his friend had gone. Fearful for his friend outside, Vince ran to the stage door and pushed it open.

His friend was nowhere to be seen and to add to the mystery there was no article of any sort beneath the window that someone could stand on to look through it. Very puzzled, Vince searched the immediate area but found no trace of his friend.

The air was full of acrid smoke and a flickering glow appeared to envelope the entire city, broken glass crunched under his feet. A screaming whistle heralded the approach of another vile explosive device. Vince ran back to the stage door and lay on the concrete steps as another explosion rocked the Theatre.

The raid returned as another wave of bombers carried on the evil work. Bomb after bomb fell around and near the Theatre. Fire bombs burst on roofs and thudded into the roadways, bursting into a hissing eye-stinging bright blue white light. Still the Theatre survived; Vince had carried out his duties in spite of the risk of death and checked all over the Theatre including the roof for damage and fire. Up to now the Theatre had been spared but surely it was only a matter of time before some bomb be it fire or explosive, would put an end to its existence. Slowly, bit by bit the hideous noise abated until all that could be heard was the crackling of fires, ambulance bells and people shouting and a low howl of a dog in the distance.

The drone of aircraft engines became fainter and fainter and then they were gone. To them a good job done, to Bath a scene of death and desolation. The once proud city writhed in the agony of smoke and fire. Then the sound that he had heard earlier came again; the sound that had pulsed fear through him. The sirens began to sound, but this time their note was constant and steady, not the rise and fall note that warned of approaching enemy aircraft; no, this long, clear note signified the all-clear; the raid was over.

Vince heaved a sigh of relief; he had survived and just as important to him, the Theatre had survived as well.

Going back into the office he began to fill out his reports. He tried to contact a few of the A. R. P. posts but couldn't get through to most of them as the lines were probably down.

Then his 'phone rang as some sector rang for information. He began to tell them that all was in order at the Theatre and there was no damage to report. During the conversation he mentioned the unusual appearance of his friend at the Theatre; the reply he got stunned him, he asked them to repeat it and without answering he slowly put the 'phone back on the hook and just stared at the wall. He then turned and looked at the window now flickering red and orange as Bath's flames lit up the night.

The message that had sent him into shock was that the Francis Hotel had received a direct hit and that his best friend had been killed instantly, at exactly three minutes past one.

At the moment of his death he had appeared at the window of Vince's office in an agitated condition, trying to tell Vince of something. Vince believes that he was telling him that he had just been killed but that he was still in existence. Vince drew comfort from this and now most certainly believes in life after death.

SEQUEL

In the 1990s, a new employee took up his new post in the Theatre; he was the new stage door keeper. He loved his job, meeting lots of people, including all the stars that came to the top class shows usually billed by the Theatre Royal. Part of his duties in those days was to stay all night for security reasons. He didn't mind too much but was a bit wary after he experienced one or two spooky events. However, he was happy in his job and thoroughly loved the perks. That is until April came.

On the first of April, as he was sat in the office reading on night duty, it had just gone one o'clock when a bright blue flash lit up the office. It was like lightening, but there was no thunder. As no more appeared he carried on reading unperturbed. The trouble was, every morning at this time a flash would appear; he was curious and even went outside to check but there was never anything to see. He did not report it as he did not see that it was of any importance. Then on 26 April he felt tingly and excited; he did not know why but he felt himself in a state of expectancy. He was restless and kept getting up to have a look round but there never was anything to see. One o'clock came and the tingling sensation returned which filled him with energy. He remarked later that as the tingling swept over him he seemed to feel stronger and absolutely full of suppressed energy, he felt he could jump up and run a marathon. He looked at his watch; it was almost three minutes past one, and as the second hand hit the three minutes mark there was this same bright blue flash. This time something strange happened. At the window, a face appeared to be looking straight at him, the features wild and agitated.

It seemed to be trying to tell him something but there was no sound. Then the figure put both hands to its mouth as if it had done something wrong; it then pointed at the doorman, shook its head and with another blue flash was gone. The window was now empty.

The doorman sat there, his heart pounding, staring at the now empty window.

The next morning the stage doorman went to see Norman the stage manager to report this strange happening. He knocked on the door and was asked to come in.

When the manager looked up and seeing who it was he said,

'Oh hello, come in Vince!'

Yes! The new stage doorman was called Vince; he was no relation and knew absolutely nothing about the Vince of 1942.

All that can be said of this story is that, in 1942, the ghost of the man killed tried to contact his friend Vince with a message. He didn't get through properly and Vince did not fire watch anymore. Maybe the ghost kept trying to impart its message but couldn't find Vince.

Now, when suddenly there is once more a Vince in the stage door, it once more tried to impart its message (as time and space mean nothing to these entities, 1990 and 1942 are completely irrelevant), but realising that it wasn't the Vince it knew it withdrew.

Well, that's a theory, if you have a better explanation let me know.

THE VOICE

It was 2 a.m. in the Theatre, but still a small crowd of staff and friends congregated in the Lower Circle Bar (now Royal Circle) of the Theatre Royal Bath. It is a strange thing about the Theatre because although it is a place of work, when the working shift is over the place still attracts the staff to socialise here. Even on days off, if a member of staff happens to be passing, it is very hard not to just pop in to mix with their colleagues and see how things are going, for such is the attraction of the Theatre Royal's atmosphere.

Tonight was one of the impromptu get togethers that took place on occasion in the 1980s.

The late bar had turned into a spontaneous party. Back stage crew members and a couple of the show members had joined the front of house staff. As the alcohol loosened tongues, various discussions were being heatedly debated; how to run the Theatre, what sort of shows would be the best to have. The most prominent subject, however, was the weird and sometimes scary goings on in the Theatre. Nearly everyone in the bar had had some form of fright or odd happening while in the Theatre.

Among the crowd in the bar that night was a small group which included Keith Pass and a few friends. Keith, a backstage technician, was discussing the sad and recent death of Jeanie, a cleaner who had worked for the Theatre for years. The topic of the discussion was the fact that three butterflies had dramatically forecast her death, as three dead ones were found in her cleaning patch just three days before she died. The butterfly legend was marvelled at, as all the predictions appeared to come about.

Dead ones apparently did signify death and live ones indicated success as proved in the spectacular appearance in Aladdin, Leslie Crowther's pantomime.

After several anecdotes of butterfly sightings and their positive results had been thoroughly analysed, the conversation swung round to the Theatre hauntings in general. Eventually, the stories of The Grey Lady were exchanged and consistency of the sightings plus the integrity of the witnesses convinced all present that there was indeed a very active ghost in the Theatre.

Keith said that although he had actually smelt jasmine during a passing of her in this very bar, he hadn't actually seen her. The small circle of Keith's friends thought it might be a good idea to go into the auditorium and see if there was any activity in The Grey Lady's box.

'Oh, I don't think so,' said Keith, 'I don't think ghosts appear to order.'

Nevertheless, he was persuaded to at least go and see.

Keith and his friends Heather, John and Bill left the bar and wended their way into the auditorium in to what is now the Royal Circle. Going to the front row in the circle they all stared at the top left hand box facing stage and willed The Grey Lady to materialise.

The atmosphere seemed right. There was only emergency lighting on and the box looked like a gaping black mouth; it really looked spooky and there was hardly any sound because with the auditorium doors closed the sound from the bar was very muted. They all felt decidedly creepy and sensed a presence. Keith, in particular, told the others he could feel there was something here, so they all scrutinised the box intently but to no avail. Nothing happened; there was no materialisation.

After about ten minutes it was apparent that The Grey Lady was not going to oblige, but although they did not know it, something was happening, something was there and something did happen.

What happened next is best told in Keith's own words.

'Heather, Bill, John and I went into the Circle auditorium to suss out The Grey Lady. Going to the front of the circle we all stood and looked at The Grey Lady box. It was very quiet, just the faint noise of chatter coming from the bar. I felt a strong sense of a presence nearly immediately and the others soon began to feel that something was odd.

I was sure that something was going to happen, but as the minutes ticked away and nothing happened I felt a bit let down. After about ten minutes we all sort of looked at each other and decided to call it a night. The Grey Lady wasn't coming tonight that was for sure. The others turned and proceeded back to the bar. I remained for a few seconds because my sense of some eerie expectancy was now quite strong. I gave the box one last look but nothing had changed, no moving shadows, no misty shape, I knew she wasn't there.

What I didn't know was that something else was there, an entity that I least expected.

I had just turned to return to the bar after my friends when a tingling numbness swept over me. It was a feeling of excited anticipation. My eyes seemed to go out of focus and locked on to nothing in particular. There seemed to be a gentle buzzing in my head and I sensed a revolving light in my consciousness. The nearest I can explain it, is when I had gas at the dentists, just before I blacked out I seemed to spin inside myself and felt a pressure closing in. The sensation I was now experiencing was very similar. I have also been hypnotised and the onset of a hypnotic trance was like this also.

At first I felt panic, then a relaxing mood swept over me, the distant sounds in the bar drifted away until a total silence enveloped me. I felt warm, calm and relaxed and then a sense of peace and happiness wafted over me, I felt really good and full of well being.

Through this pleasant trance-like state a female voice cut through loud and clear. It was shouting my name.

"Keith, Keith, I'm down here Keith. I'm still down here Keith, I'm still here. It's alright, Keith, it's alright."

The voice was coming from below the circle; it was down in the stalls. I didn't find this unusual as I recognised the voice, it was one of the cleaners, and part of her cleaning area was in the stalls.

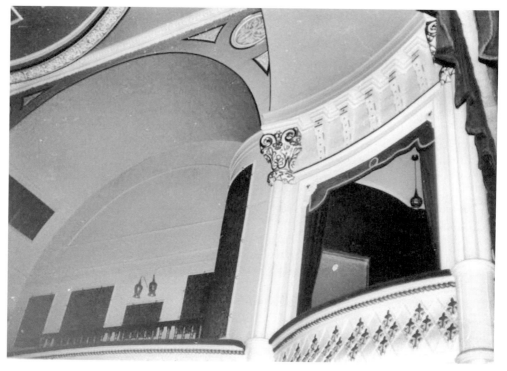

The Grey Lady's box.

My sleepy mind tried to fathom why she was shouting my name and furthermore what was she doing at work at 2 o'clock in the morning because Jeanie didn't start work until...

JEANIE????

An electric shock seemed to explode in my consciousness, snapping my mind back into sharp focus and reality.

That was definitely Jeanie's voice I could hear, loud, sharp and clear, there was no mistake it was without doubt the voice of Jeanie. The trouble was Jeanie had died last week.'

Keith was trying to tell them what had happened but all he could muster was a shouted garbled nonsense and wildly waving arms. Eventually, when he calmed down and made sense they all went down into the stalls but of course, there was nothing to be seen.

However, the next morning when the cleaners came in, Jeanie's patch was found to have been cleaned. The floor was damp and clean as if just mopped (lino in those days).

The brass work gleamed and shone as if just polished, the stalls bar (now the vaults) had been tidied, dusted and polished; everything that Jeanie would have had to do was already done.

This mystery cleaning occurred on the same day of the month for the following three months, and then stopped.

STEVE'S ANECDOTE

As I was compiling this version of the book I re-established contact with a friend of mine who at one stage became Deputy Front of House Manager. He had moved to Wales to further his career and we lost contact for a while. During our renewed relationship I mentioned I was updating the ghost book and had he had any experiences. Yes he had, and would forward the details. It is not a major event just a small anecdote, but it does show that there are numerous little tales like this in the Theatre; unseen presences and perfumed smells.

A reproduction of this letter can be seen opposite, on page 59.

THE LIVING GHOST

Early one morning Jenny Brooks descended the stairs from wardrobe 5. As she was going down she was surprised to see her friend Madeline coming up.

Jenny was carrying a flimsy dress and was concentrating on not snagging it on any protrusion.

She was quite pleased to see her friend who had been very ill and had been off from work for quite a while. As they passed each other, Madeline spoke to Jenny and said:

'Oh, Jenny, I am so pleased I saw you before I go, take good care of yourself won't you?'

Jenny couldn't help noticing how pale she looked, her skin looked almost transparent.

Jenny returned the greeting and carried on her careful way with the dress.

At the foot of the stairs she saw her friend and workmate Peggy. Jenny remarked to her that she was very pleased to see that Madeline was back.

If this was the case, it was good news, agreed Peggy, because Madeline had given cause for concern with her long illness. Peggy asked for the time. Jenny looked at her watch and saw that it was twenty five past ten.

Jenny then stopped and said to Peggy:

'I've just remembered what Madeline said to me, she said she was pleased to see me before she had to go. What would she have meant, where could she be going?'

Peggy, of course, had no idea and Jenny continued on her way; she would go up later and see how well Madeline was and where it was she thinking of going.

Several hours later Franz, Madeline's father, arrived and called Jenny to his office. Upon entering Franz told her he had some bad news for her.

'Look, I'm sorry to have to tell you this Jenny, for I know that you were very close, but you see, well, there is no easy way of saying this but our poor Madeline died in her sleep this morning.'

Jenny was stunned as the truth sank in.

'What? But I, but,' Jenny stumbled over her words. 'Do you know what the time was Frank?'

'Well, yes I do actually, because as she drew her last breath the clock chimed the half hour. It was exactly half past ten this morning.'

At twenty five minutes past ten that morning Madeline had spoken to Jenny on the stairs.

Jenny had seen and spoken to the spirit of a live Madeline, five minutes before she departed this life as we know it.

Madeline knew she was about to depart this life and tried to see her friends before she did.

MICHAEL GRAHAM YOUNG
Chartered Surveyors
Residential & Commercial Property Consultants

7th February 2000

Mr M Cadey
98 Lower Oldfield Park
Bath
Somerset
BA2 3HS

Michael Graham Young FRICS
Colum Buildings
13 Mount Stuart Square
Cardiff Bay
CF1 6EE
Tel: (01222) 465466
Fax: (01222) 480715

Malcolm,

It all began just before we opened up for the evening performance. If I remember the show was the one with Vanessa Redgrave in and I think it was a Shakespear play but don't quote me on that.

Adam and I were on duty in the Stalls that evening, we were stood just inside the doors that lead to the auditorium. We were positioned so we could see the entrances to both the Ladies and Gents toilets, there was no-one in that area exept for the two of us.
From the direction of the Ladies we were aware of a presence and yet saw nothing, but we could smell the aroma of what seemed like Parma Violets gently moving towards us.
We both noticed a slight drop in temperature as this gentle breeze brushed passed us and headed in the direction of the Gents.
It then, in the space of no more than a minute came back round and then was gone.

We then had to open for the performance and thought nothing more of it, although Adam did feel uneasy about what happened and at the end of the performance he just left and I locked up on my own, it didn't bother me in the slightest as I didn't feel threatened in anyway.
As I remember this show was on before Panto season around Sept/Oct 1986, you would need to check on that though.

I hope it is a usable story for you, sadly it is my only experience.

Bye for now

regards
Steve

In association with
ALLIED
SURVEYORS
PLC

Witness Steve's letter.

Jenny was not unnerved by this event; indeed, she gained a lot of peace in the knowledge that death is not what it seems.

PSYCHIC ATTACK ON MARIE

'I'm here, Marie. I'm ready.'

Avril Angers, a star of 'Cinderella' called to Marie Marsh the stars dresser, who, anticipating the call was already on her way to wardrobe 5 to collect Avril's costume, the dress of the Good Fairy.

'On my way love, won't be a minute'.

Reaching the wardrobe, Marie hurried inside; as she entered, she checked that the heavy weight was in its place at the door. This was a large, round 28 lb weight used to prop open the door. During the show, Marie would have to rush in and out with different costumes, and a door swinging shut could prove rather a nuisance.

She scanned the colourful array of costumes that brought the fairy tale alive to the excited audiences. The fairy dress that had just been freshly steam-cleaned outshone its companions with its scintillating beauty. Being a very conscientious lady, she very carefully took down the dress and, arranging it tenderly over her arm, she slowly made her way to the door. As she walked she watched to see that no part of the dress brushed against the floor, as dust smears wouldn't look well in the limelight.

As she carefully carried the beautiful dress she became aware of unseen company; normally this didn't disturb her for she was quite used to having the company of an invisible companion on her journeys around the Theatre. She had no fear of this strange companion, for it always gave her a feeling of comfort. As Marie often remarked:

'Why should I be afraid when it loves the Theatre like I do, no it's friendly, whoever or whatever it is'.

Marie has also heard her name called by a soft, gentle female voice. This phenomenon has been heard by several of the Theatre staff. Although soft and low, it is clear and distinct; it calls the person's christian name once, sometimes twice.

The first time this happens to anyone they are usually alarmed by this shadow sound, a voice without a mouth and words without a tongue. Any fear generated by the initial shock is quickly dispersed by the warm friendliness flowing from this intangible being. It is very close, as if stood with its mouth next to one's ear.

But tonight something was different, the feeling wasn't the same. The calm, friendly feeling that Marie usually felt was replaced by a definite sense of hostility. Instead of the feeling of peace, she felt only a cold apprehension. The inside of the wardrobe grew cold, she felt she was being watched by something monstrous, something evil.

She hurried to the door of the wardrobe; she wanted to get out as fast as possible, away from this dreadful feeling. Even in her fear she still was careful not to let the dress catch on the doorpost and slowed down as she passed through.

That is, she meant to slow down, but as she passed half way through the doorway the door, with a whoosh and a bang, smashed into her side with crushing force, badly bruising her arm and shoulder. The impact crushed her momentarily between door and post, and then the violent impetus catapulted her down on the floor. There she lay sprawled, tangled up in the now crushed fairy dress. As she hit the floor, the door slammed shut with a terrible bang, filling the air with dust.

For a few seconds Marie lay dazed, her arm and shoulder throbbing with the unexpected blow. Although distressed her first thought was of the dress. Marie was proud of her role of dresser of the stars, and to her the dresses in her charge were always the first priority.

Climbing shakily to her feet she anxiously checked the dress for damage. She began to make her way painfully to Avril's dressing room when Avril came running to meet her.

'Oh, Marie, whatever's happened?'

'Scream? I didn't scream, I'm sure I didn't, did you hear that bang?'

'No, I never heard a bang, just a scream. What happened?'

'The wardrobe door it slammed on me, I've hurt my arm.'

'I'm alright don't worry.'

'I heard you scream and came as fast as I could.'

'Goodness me how did that happen?'

Marie stopped, puzzled; yes, how did happen, the door couldn't have slammed; the weight was there, she had seen it and what had slammed it so violently?

'Just a minute, there's something wrong up there', she said.

Handing the dress to Avril she turned and went back to the wardrobe. Avril, by now very nervous, followed her.

'What's wrong Marie, there's something wrong, what is it Marie?'

'I'm not sure yet, its jus- ... Oh my God, look at that.'

'Wh-... what am I looking at?'

Marie was stood pointing at the offending door. It was wide open and the weight was firmly in its place. There was absolutely no way anyone could have passed Marie and Avril to open it, as there was no other entrance to it.

'The door for God's sake, it's open again', stammered Marie.

The two ladies suddenly felt a cold chill and apprehension gripped them.

'Marie, I feel odd. Look, the hairs on my arm are standing up, it feels like static electricity. It's a ghost isn't it? Oh dear I don't like it.'

'Neither do I, let's go.'

Two very apprehensive ladies turned and retreated to the dressing room. The pantomime opened and soon Marie was caught up in the flow of work, she had to enter and re-enter the wardrobe several times, but with the laughter, music and the back stage bustle of a live show she didn't have time to dwell on her earlier experience. Apart from feeling slightly nervous and being very wary of the door, the evening passed without incident.

Now it was quiet, now it was still, and the happy crowded auditorium had transformed into an empty cavernous silence. The stage, which a while earlier had been a colourful display of a fairy tale magic, now stood deserted; the cast had dispersed back to their digs or into the circle bar for a drink and a chat with the remaining stage crews, the dull murmur of their voices being the only sound to be heard.

Marie did not have any company; she was alone among empty dressing rooms and deserted corridors.

She half thought of calling the stage doorman to accompany her, but decided to brave it alone; over her arm draped the fairy dress which had to be put away.

Marie had to once more return to wardrobe 5 but this time she was all alone.

Well, this won't do, she thought, and squaring her shoulders she marched briskly up to the wardrobe, intending to hurry in, hang up the dress and hurry out.

She reached the doorway and stopped dead, she couldn't ... she couldn't go in. Her nerve failed completely at the last moment. The door looked like a lurking predatory animal and cold chills swept over her, raising every hair on her body. The wardrobe exuded a hostile atmosphere, there was something in there, and it was malevolent. There was no way that Marie was going in there, and slowly she began to back away. She kept her eyes fixed on the ominous cavern that was the wardrobe. The rows of colourful dresses looked more like rows of wraiths and writhing spectres that waited to swamp and suffocate her.

She dared not turn her back for she felt that something dreadful would leap out onto her back. So, very slowly she inched backwards. Then she felt it.

There was something behind her.

Marie felt the prickle on her neck and knew that a presence was immediately behind her. Just as the level of fear rose she heard a voice. A voice that whispered soft and low, a voice that was friendly. It spoke once; it spoke one word very slowly and distinctly.

'Marie.'

It was the gentle voice of her familiar companion. It was the voice of understanding, of love and a voice of gentle power like a steel bar wrapped in velvet. It was also the voice of victory, for this was the voice of the Theatre's friendly spirit.

Hearing the voice, Marie's fear vanished like a drop of water in a white hot furnace, a feeling of peace and calm enveloped her, and the ominous presence was swept away like tissue paper in a gale. The Theatre once more felt homely to Marie for she had always regarded it as her second home. She sent mental thanks to this spirit of power and good; just like the cinema cavalry, it had arrived at just the right time.

Looking once more into the wardrobe she saw only rows of brightly coloured costumes, the trappings of the fairy tale had replaced the rows of wraiths and spectres. The room, which had looked so ominous, now looked cheerful and homely and, far from being hostile, it looked quite pleasant.

Marie walked into the room and after hanging up the dress she paused and looked around. Fine, she thought, its home again; all was peaceful, all was well.

Switching off the light she walked down the semi-dark corridors towards the stage door completely unafraid.

Apart from the bruises appearing on her arm and shoulder, the distressing experience of the earlier evening was fast disappearing from her memory. Whatever malicious being had cruelly slammed the door on her had been routed by the Theatre's power of good.

To this day, Marie has no qualms about walking anywhere in the Theatre be it light or dark, for she knows that the Theatre protects its own, just like the butterfly; maybe they are one and the same.

No, Marie never has any fear in the Theatre, why should she?

The Theatre and Marie are friends.

DEREK'S SECOND ENCOUNTER

Derek had just completed restocking the optics cupboard, so that his wife, who worked behind the bar, would have less to do when she came on duty. He had heard from the bar a small sound of something falling. Leaving the cupboard, he went into the bar to investigate. He saw the price list that he had just hung up was now face down on the bar. It could just possibly have fallen of its own accord, except for the fact that it was at least three feet horizontally away from the hook.

Derek was not alarmed by this phenomenon, it had happened before. It was his old friend Jeanie who, although she had died recently, had made her presence known to several of the staff.

In her living state she was a bit clumsy, always knocking the price lists down while cleaning. Derek, who has a very dry sense of humour, would chastise her in a friendly way. Seeing the price list in that position, he guessed straight away that it was Jeanie up to her tricks again. Putting back the list he spoke out loud.

'All right Jeanie, that's it, why don't you knock the whole place down?'

Hardly had he stopped talking when an almighty crash sounded from the passage

behind the bar. Derek, the Bar Manager, jumped in alarm as he had just been taking the optic bottles out of the optic cupboard which was out of sight just round the corner at the rear of the Stalls Bar. The sound was of a stack of bottles falling to the ground and breaking. Before Derek could move, a series of crashes followed. It just sounded like row after row of bottles falling one after the other and breaking. The sound of smashing glass nearly deafened him. Derek rushed round the back to the optic cupboard he had just opened. The cupboard is always kept full of the various spirits that are sold at the bar, and their position in the cupboard is always precarious. This is due to a ledge that protrudes near the base. Derek was quite worried as each bottle was worth several pounds, and he had to account for them. He would have to assess the damage and wondered how he could justify the accident.

When he reached the cupboard and stopped, he couldn't comprehend what he saw. Every bottle was in its rightful place, not one had even moved, never mind fallen. The floor was empty; there was nothing there that could have made that noise. After a thorough check of the surrounding area and neighbouring bars it became clear that no bottles had fallen and certainly none had broken.

Derek said that he was sure it was the spirit of Jeanie attempting to frighten him in return for all the teasing he had given her. Did she succeed, you may ask.

'I'll say', Derek will reply, 'she scared the pants off me.'

Jeanie's spirit, on occasions, still causes mischief in the bar, no matter who is running it. She did not stop after the bar changed into the vaults.

A HAUNTING DAY

Morning, the First Oddity

Humming gently to herself, Helen, an attractive, petite, blond waitress in the Theatre vaults, carefully arranged the layout on the tables in the Theatre Royal Vaults restaurant. It was a friendly atmosphere in the vaults and Helen was happy in her work, although when it was busy it could get rather stressful. It was mid morning and at this time all was quiet and peaceful, and consequently she felt relaxed and content in her work.

Helen was about to stop for a coffee when she heard her name being called by the Manageress.

'Helen, we need tea towels; nip down to the laundry would you?'

'What about the tables?'

'That's OK, plenty of time for that when you come back, but we need the towels now.'

'OK', said Helen, going to the counter and picking up the bunch of keys for the pass door.

At the end of the horseshoe-shaped corridor outside the stalls auditorium was a combination lock door which led to the upper floors and boxes B and D. The door was propped open with a large ashtray so she had no need to remember the combination.

Passing through the open door she climbed three steps and stopped at a door on the right hand side wall. This door was locked and she had to use a key to unlock and open it. This was the pass door giving access to the dressing rooms, staff rooms and the laundry.

Going through she re-locked the door and stepping into the connecting passageway she made her way to the laundry.

After a chat with her friend Linda she picked up a pile of clean tea rowels and set off on the return journey. As she approached the pass door the lights suddenly flickered and nearly went out, then dropped to a bare minimum making visibility poor.

Half guessing and half feeling her way Helen finally reached the door. Helen then ran into difficulty, balancing the towels with one hand, and trying to find the right key in the dim light was extremely difficult. She kept trying keys that looked like the right one but couldn't see the lock properly either, she was getting very angry and frustrated as the towels were heavy and kept slipping. Just as she thought she had the right key she lost her grip on it and the entire bunch of keys fell to the floor. Trying to balance the towels she now had to stoop down and retrieve the keys. Just as her fingers closed on the bunch of keys she saw something in her line of vision that made her pulse rate shoot up. About a metre away from her at ground level she saw the hem of a grey dress from which protruded the toe of grey footwear; she was also aware that she could smell a faint perfume. Helen felt a tingling fear flow through her body and she didn't dare raise her vision to see the rest of the creature. All she could think of was the fact that The Grey Lady was standing next to her.

Still keeping a wary eye on that foot she straightened up and tried to find the right key again. She was all fingers and thumbs; her hands were trembling and she was in danger of dropping the keys again. One after another she inserted a key, but it wouldn't turn.

'Open, please open, open', she thought, half pleading, half commanding.

A sense of panic began to rise in her. She stole another glance at the grey foot and to her horror it began to move. The foot slid slowly forwards from under the hem of the dress.

It was coming towards her and it was only a metre away from being in her space.

Although her mind was reeling, her fingers apparently working on their own, she carried on trying keys in the reluctant lock.

'Oh please let me through, open, open ...'

Click; the lock turned, the door opened and Helen half fell through the doorway. As she fell through the door she snatched out the key and spinning round she thrust it into the lock and re-locked the door. As she stepped back away from the door she heard what sounded like a sigh, followed by a swishing sound. It was the sound of a heavy dress dragging on the floor as if the wearer had turned suddenly.

Helen leaned on the wall to get her breath back, and then ran into the vaults, where wild eyed and breathless she blurted out her experience to one of the staff. The Manageress then walked in.

'Oh there you are. Well, where are the towels?'

'Sod the towels,' cried Helen, and threw the keys on the floor.

The other staff explained what had happened and they found half the towels outside the pass door and half inside.

News of another Grey Lady sighting soon spread and staff members comforted Helen as best they could.

Shortly after this, Helen left the Theatre.

Afternoon, The Second Oddity

Taff cursed as he lugged two crates of beer up the many stairs in the Theatre. He was a member of the front of house staff but had been given extra duties of helping to

restock the four bars in the Theatre. The Stalls bar was easy as it was virtually next to the cellar, and the Dress Circle wasn't too bad but it still had stairs to negotiate. However, Taff was now heading for the Upper Circle and after that would be the Gallery, a lot further still.

'Why on earth haven't they installed a lift?' he thought.

Gritting the order slips in his teeth he puffed and heaved the heavy beer crates up towards the bar.

As he climbed upwards he thought about the odd event he had been told about. It would seem that Helen from the vaults had actually seen The Grey Lady.

He had never seen anything but on occasion he had noticed an odd atmosphere which always made him glad of company.

Reaching the Upper Circle bar he went in and gratefully put down the crates. Taking the orders out of his mouth he began to check if he had fulfilled everything. As he was doing so, he heard a faint sound. At first it didn't register with him, then he heard it again. It came from inside the auditorium and sounded like a long sigh. Strange, he thought, but carried on checking; there it was again. A long drawn out sigh and what sounded like low muffled moaning.

He was now very curious but also very wary; he began to feel that odd feeling he had felt now and again, a nervous tingle swept over him but he still went to investigate. On reaching the auditorium door he listened intently again. There it was again; someone is playing tricks he rationalised, so he swiftly pulled the doors open to confront whoever it was that was making these stupid sounds.

His eyes swept over the empty seats and then focused on a strange sight.

Taff saw three odd shapes like stooped figures in drapes, two of them were barely solid, just an impression of something being there but semi-transparent; the third one was more solid and was a grey colour. They were moving or drifting diagonally through the rows of seats, which of course, is impossible to do. The sigh appeared to come from the leading, more solid shape and the moaning was coming from the two shadowy shapes. Then, as if aware that that they were being observed they all stopped and appeared to slightly turn in his direction as if looking at him; the sound then changed to what sounded like small birds chirping. As Taff looked in amazement the three shapes merged into one and condensed into a black rectangle about two foot long that flickered, changed into a triangle and at tremendous speed flew up towards the chandelier where it vanished.

Taff closed the door and walked slowly down the stairs to the Foyer. He went up to the Box Office and placed the drink order forms on the counter.

Talking in a loud voice to no one in particular he said:

'Tell the chief, there are the orders, the beer's in the bar, I won't be back, after what I have just seen tell him he can stuff the job, stuff the Theatre and stuff the ghosts, that's it I've had it.'

With that, he stormed out of the Theatre.

He went in the Garrick's Head and ordered a stiff drink where he related his story to several people in the bar. He then left the Theatre, his job, and Bath, returning back to Wales, never to return.

Evening, The Third Oddity

I was in the Theatre that evening and had been presented with the details of the day's events which I found rather intriguing because there was a definite pattern emerging with some of the sightings. Different people at different times were seeing or experiencing similar things. I was stood in the Stalls corridor quite close to the Theatre Vaults restaurant entrance. I had just been told about Helen's experience and was looking at the area where she had been working that morning. Venetia, another waitress, was in the process of laying the same tables; she was a very pretty girl with rich black hair. She was working quite swiftly down the row of tables placing the knives and forks neatly into place; I had a good view of what she was doing. Someone called my name and for about two seconds I was distracted from the activity in the vaults.

As I turned to see who was calling me I heard three distinct slapping sounds coming from the restaurant, but thought no more of it. As I made to move away I heard a cry from inside the vaults and turned just in time to see Venetia come running up the steps to me.

'Malcolm, quick, quick, come and see, come and see, look.'

When I followed her into the restaurant, at first I could not see what was making her so agitated. Venetia was trembling quite violently and pointing to the tables she had just been laying. I still did not see what was amiss when she said:

'The leaflets, look, the leaflets they jumped out and placed themselves on the tables as I passed them, look.'

Now I had been looking at those tables as she set them up and there were definitely no leaflets on the tables. The leaflets were actually kept in plastic holders attached to the wall. For them to get on the table they had to lift right out the holder, fly horizontally one metre and then negotiate a bunch of flowers to put themselves where they were. Which was at a slight angle at the top of the spoons and every leaflet was in the same place at the same angle as the rest, as if it had been measured and angled precisely. The girl was obviously shocked and stared at me for an explanation. This I couldn't give, however, I could verify her story, as I had observed that there were no leaflets on the table as she passed and she would not have had time to place them there herself. Also I recalled the three slaps I heard followed immediately by her cry. I actually heard the sound of the leaflets dropping and the interval between each one was infinitesimal, a very rapid sound as fast as a machine gun. No one could have placed them at such a speed especially in the precise manner they had appeared.

Venetia then said that as she heard the slapping sound she spun round and saw the last one shooting out of the holder and slamming down on the table. The leaflets did not yield a clue, they were not of anything exciting or unusual, just an advert for Wookey Hole. Well, it has got a witch has it not?

The significance of this event left me puzzled for a while, until I recalled a story from the Garrick's Head a few years previous.

On the walls in those days were loads of photographs of stage and screen stars going back several years. One night while the bar was open, three of the photographs on the back wall in the left hand side bar detached themselves from the wall. They flew horizontally across the bar over the heads of the patrons and banged themselves loudly on the bar counter. They too were placed symmetrically as if measured and angled with precision.

This event happened at 8.10 p.m. just as the 'Ghost Walks of Bath' was setting off on its nightly ghost visitation. The landlord called them in to see what had just happened and they all had heard the three bangs and they all saw the shock and fear on the patrons' faces. Three of the walkers said that they had had their money's worth and went back to their hotel.

It was told to me later that the three thespians featured on the photographs died within three weeks of the happening. That is the only similarity of this odd behaviour but if the event in the Garrick's Head was a warning I'm afraid I cannot yet find anything to substantiate that it was a warning to the Theatre.

Unless the witch of Wookey Hole is now really dead.

THE VANISHING MAN

George felt good; it was the first day of his holiday. He had spent most of the day travelling, but now he was here in Bath. He was holding his first drink of his holiday, and was standing in the foyer of the Theatre Royal Bath. He took a drink from his glass and looking through the glass of the doors, he could see the other visitors to Bath strolling slowly pass. It was getting on for ten at night but it was still very light. George had come to the Theatre to see his brother-in-law who was a member of the front of house staff. He had arrived a bit early as the show had not yet finished and his relative was still working. To pass the time he had bought a pint and had walked into the foyer to absorb the atmosphere of Bath. Noticing a tower opposite had a clock he noted the time was ten to ten.

'Ah well, no hurry' he thought.

He was beginning to feel most relaxed, so taking another drink, he basked in the luxury of not worrying about time.

As he raised his glass he was aware of a movement. Out of the corner of his eye, George saw a figure descending the stairs from the Upper Circle. He half turned to see who it was and saw the figure of a man dressed in full evening dress. George didn't know who was who in the Theatre and assumed that as the show wasn't yet over; it must be the Manager or someone important.

As the man descended to the foyer, George felt a peculiar sensation in his stomach, as if something wasn't quite right. He couldn't put his finger on it but the scene somehow appeared unreal, just an odd feeling. Maybe drinks are not allowed in the foyer, he thought. He glanced down at his drink wondering if he should say good evening or something.

Glancing back he felt a stab of fear, the stairs were empty, the man had gone, vanished. There was no way that the man could have returned up the stairs, there was nowhere for him to have gone in the foyer. In that brief glance to his glass the man had disappeared from George's vision. What he had seen was decidedly spooky, and he now felt alone and vulnerable and so he hurried back into the bar.

Later, when he told his story to his relative, it transpired that there was already a tale of a man disappearing while on his way up from the stalls. This man also wore evening dress. This event took place back in 1948 and had never been reported since. Now for some reason it appeared that the ghost had walked again just to disappear in the presence of a complete stranger to the Theatre.

What is his purpose? No one knows, but what we do know is that he is still roaming the Theatre.

JULIANNE MACKRELL'S STORY

Dress Circle Bar, December 1997

This account of a ghostly sighting by Julianne Mackrell is related in her own words in the first person. Her original transcript has been copied word for word as it reflects her immediate thoughts at the time.

"'Twas the time during Panto when all through the house the patrons were transfixed on the stage. The buzzer had gone, to which they were unaware meant '5' minutes until the interval began. I sat idly conversing with a colleague when another colleague entered the bar, walked slowly along in front of the bar, then just as slowly back out, however the door did not slam like the norm. This same colleague dressed all in black with no hat and his back to us returned again, walked beside the bar until he was 1/3rd of the bar away from the wall. It was at this time I heard a rustle from the auditorium and asked my conversing colleague:

'Who is out there?'

As my back was to the door.

His reply was the name of the colleague that I assumed I was seeing at the bar, as I raised my arm and pointed saying, 'So who is that?'

The figure vanished!

I have no explanation for this – however it was at no time 'spooky' as I imagined an encounter with a 'ghost' would be. On telling this tale many people have offered their explanations, but I hadn't had a G&T in days. Some would say it was the duty manager who often frequents the Dress Circle (formerly the Upper Circle) bar apparently, but he is not in the habit of disappearing.'

Author's Note

The description of this ghost is identical to the one seen in the vicinity by many people since 1947 and is known as 'The Vanishing Man'.

George's encounter related in the story 'The Vanishing Man' saw it on its way down from this area.

In the late 1970s a patron was following this 'person' up the stairs wondering why he was wearing a dress suit but as they reached the turn at the upper circle level the 'Creature' kept walking straight on and vanished through the wall into the circle bar.

This is where Julianne saw the same figure leaning on the bar in a dress suit as worn by the managers.

There have been odd events in the haunting area, moving shadows, sounds of soft footsteps entering, Jasmine perfume and a hooded figure usually seen out of side vision.

Jackie Greenslade saw The Grey Lady here. Her story has been documented on the TV series, *The Why Files*.

JANE AND GRAEME'S ENCOUNTER

Friday 8 January 1998, 7.30 p.m. Pantomime time

In the Grand Circle at the top of the building a warning bell sounded. This heralded the rush of excited children and their reluctant parents as the rope barriers came down. Bracing themselves for the coming onslaught stood Jane the usherette, looking down the stairs, and Graeme the stock controller, who was standing in as the sales vendor at the top of the stairs. Between them both, behind Jane but in front of Graeme, was a heavy door set in the wall; this was the entrance to the lighting box. Jane now takes up the story.

'Graeme was checking his tray and I was looking down the stairs anticipating the rush of excited patrons. Suddenly I heard a whooshing sound and the heavy lighting door opened with tremendous force, it caused a fierce rush of air that blew my hair forward. The wind, which persisted for a second or two, was icy cold and made the hairs on my arms stand up. I spun round to see that the lighting door was wide open and swinging idly on its hinges. Graeme exclaimed:
"What the hell was that?"
We both at this stage had no thought of anything paranormal and thought someone had rushed past us from the office area and gone into the lighting box. Graeme and I went to the door and checked, there was no one in the box and all windows were firmly closed and most certainly, no one, but no one had come out of the box. It dawned on us both that the door opening and the accompanying wind had no logical explanation. We now both felt distinctly uneasy about the event.
We were then enveloped in the usual rush of excited children as the patrons poured in.
Later on in the bar Fee Radcliff, the head bar person, suddenly started and span round stating that she could smell Jasmine, as she spoke I also smelt a strong Jasmine perfume, the scent of The Grey Lady. It wasn't just a faint smell it was powerful and close.
Glancing at each other we both thought the same thing. I spoke first.
"She's here isn't she?"
Fee interrupted.
"The Grey Lady, yes you can feel her can't you? She'll give us a sign if she is here. Come on let us know you're here."
Before I could answer there was a muffled explosion in the fridge. When we opened the fridge door there was glass everywhere. A bottle of lager had exploded the instant we had mentioned The Grey Lady. This may not sound dramatic but I assure you that if you had been there you would know as we know that something out of the ordinary happened that night. It is just something you know and feel it is very, very real.'

THE LIGHTING BOX, 1960s

In the 1960s, a Mrs Michelle was working in the limelight box, which is situated on the top floor adjacent to the Grand Circle bar. As she concentrated on keeping the

limelight on the principle character she became aware of the lighting box door opening and someone entering the box behind her. As this was a scene that demanded accurate lighting on the stage movement she was unable to turn round and see who it was, although she was acutely aware that someone was behind her and for some reason had not spoken.

When she was able, she turned around to see who it was. She was quite surprised to see that the box was empty. Looking back at the stage she once more sensed someone behind her but on glancing back again nothing could be seen.

Trying to ignore this persistent feeling, she applied all her mind to keeping the light in the right place. However, the sense of a presence grew stronger. She was aware of a strong perfume smell and felt the hairs on the back of her neck prickle. She felt a waft of chilled air sweep over her, as if someone had opened a fridge door.

Spinning around, this time she was shocked to see the figure of a hooded lady apparently crouching in the corner. The lady seemed to be rocking or nodding, the garments had a dull silvery sheen and then to Mrs Michelle's horror, the figure slowly faded away, leaving her once more alone in the box.

Not for long though, three seconds later the box was completely empty because Mrs Michelle had run out for help and a relief. She wasn't going back in there in a hurry.

The strange thing is that as Mrs Michelle left the lighting box she automatically slammed the door shut.

However, as she reached the corner of the stairs leading to the lower levels she felt the same cold air on her back. Terrified, she glanced behind her see that the lighting box door had opened wide so forcefully it had bounced back and was swinging wildly to and fro as if someone or something had catapulted through at speed. She was aware of the cold wind rushing past her down the stairs and then it was gone.

A very frightened lady ran downstairs for help. She refused point-blank to work in the Box alone again; she would only work there if someone accompanied her.

THE THING

Paul had just completed locking up after the night's show. He slammed shut the outer door of the stalls, and turned to walk back through the corridor that led to the stalls.

The corridor is not straight; it has a sharp bend in it which obscures vision from the doors to the stalls. Just inside the doors there is an old ticket office now used as a cloakroom. Paul half expected to see a ghost sat in there one night. However, ghosts were far away from his mind that night. He turned the corridor bend and headed for the stalls.

The walls of the corridor were bare except for a couple of tattered old posters of long departed shows. One poster caught his eye. Paul remembered the show, one of his old friends played in it, so he stopped to see if his name had appeared in the supporting cast. If Paul had known, he would not have stopped in the corridor but would have hurried away from there as fast as possible. For Paul was not alone in the corridor that night, something rather horrific was about to happen.

Paul continued to study the poster, unaware of the insidious being that was forming behind him. Scanning the list of names Paul found the one he was looking for. Ah! That was it, he thought, when he felt a prickling sensation sweep over his back...

Paul knew, without any doubt, somebody or something was behind him. He felt as if he was in a field of static electricity and every nerve was tingling with fearful anticipation. Something unearthly was behind him and Paul was afraid to turn round and see what it was.

He continued to stare at the poster, trying to normalise things, but he couldn't focus on the words; he was conscious of the presence of something behind him and knew he would have to face it whatever it was.

Paul steeled himself to confront what ever it was behind him, and when he had psyched himself up to it he swiftly span round.

He wasn't prepared for what he saw and felt his mind go fuzzy as it strove to comprehend the extraordinary image that his unbelieving eyes saw.

Upstairs in the Circle Bar, the Deputy Bar Manager completed his tidying up and began to wonder where on earth Paul had got to. He lit a cigarette and waited a few moments. After smoking part of his cigarette he decided to chase him up a bit.

At that moment he heard footsteps running very fast from the direction of the stalls. That's strange, he thought, I've never known Paul to run anywhere. Walking to the bar door he looked to make sure that it was Paul coming.

Out of the corridor rushed Paul, sheer panic registered on his face. He ran in obvious terror straight for the Deputy Bar Manager.

'Get out, get out!' he cried.

The Deputy Bar Manager grabbed him as he sought to rush pass him.

'Hold it, hold it. What's this then?'

Paul, still frantically trying to pull himself free gasped:

'It's there it's down there, for Christ's sake we've got to get out.'

'What's where? Now come on, pull yourself together, know what I mean.'

After some pulling by both men Paul calmed down enough to try to explain.

'I've just seen a bloody ghost or something.'

The Deputy Bar Manager was not going to accept that statement without further explanation, even though he was quite alarmed at Paul's behaviour and appearance.

Paul's attitude was indeed quite out of character, he was usually quiet and calm, seldom ruffled and not given to flights of fancy. Carl told him he needed a drink and took him into the bar. After pouring him a drink, he sat down with him at a table and asked him to explain as calmly as he could, what he thought he had seen. After a few moments Paul began, and here is his story.

'I was just looking at a poster in the stalls corridor, when I felt an awful tingling down my back. I knew someone or something was in the passage with me. I felt really scared even before I turned round, and when I did ... Oh bloody hell', Paul broke off and had another drink. When he had composed himself he carried on.

'When I turned round there was this thing, Ugh!' he shuddered. 'It was the rough shape of a human but blurred at the edges ... it seemed to be made of swirling black smoke that pulsed in and out.

It was as if it was trying to form but couldn't quite make it. But its face, God that was awful, it, it ...' Paul stopped and had another drink. 'Its face was swirling like the rest of it, and it changed rapidly from one face to another as if there were hundreds of faces trying to get through at once. Then it, the thing, it started to sort of lean towards me, God I thought it was coming for me. If it had touched me, I'd have died, I know I would.'

'*I tried to yell for you to come, but nothing happened, my throat wouldn't work, I wanted to run but I was paralysed, there was a rushing noise in my ears, I thought I was going to pass out. Then where its mouth should have been, a black hole seemed to appear. At first it looked as if the thing was going to give a terrible scream.*'

'Hey, are you on pills or something?' interrupted Carl.

'I wish to hell I was', replied Paul. 'That would have been a reason for seeing it.'

'How much have you had to drink?'

'Not much, now look, what I saw, I saw. It was there, my God it was there.'

'Carry on.'

'Well as I said, I thought this thing was going to scream because its mouth opened real wide, and I can tell you I didn't want to hear it. Well anyway, and this was terrible to see, its mouth or whatever it was just kept on opening, until the whole head part of it, was one big gaping hole. Then the rest of it, the tail of this thing sort of flowed up into the hole like smoke going up a chimney and when the last bit had gone through, the edges rolled inward and it was gone. Thank God!'

'Oh come on, you expect me to believe that, you must be kidding, know what I mean.'

'I don't expect you to believe anything and what's more I don't care what you believe. I know I saw it, and I don't give a damn what you or anybody else thinks.'

'Fair enough, but I'm off down the stalls to see if anybody's down there.'

'Please yourself, but you won't get me down there again tonight.'

The Deputy Bar Manager did go down into the stalls; he wasn't sure what to make of Paul's story.

But the Deputy Bar Manager was ex military police and didn't scare easily. After searching the area that Paul had described and seeing nothing he was about to give up when he felt an ominous sensation behind him. He sensed something was behind him but did not turn round to find out what. For the first time in the Theatre he sensed an atmosphere that he found quite frightening and disturbing.

On his return to the bar, he admitted that the weird feeling he had had, made Paul's story more credible. There is now no doubt that Paul experienced something frightful down there. What it was or why it appeared in that dreadful form is a secret shared only by the rest of the Theatre's whispering shadows.

WHAT WAS THIS THING?

After reading about the Thing you could be forgiven for thinking maybe there was a touch of over exaggeration, as it is such a graphic story. However, years later, the Front of House Manageress Phyl Smith received a letter from a patron. This person had attended a matinée performance and had apparently enjoyed the show; being a friend of the Manageress, she had sent a thank you letter for the service she had received. Innocently, she also asked a very chilling question. Here is her letter.

'Dear Phyl,

Thank you very much for the splendid escape mat! I crept out at 10 to 5 – no problem with the train – departed ON TIME! At 9 mins past & I was waiting for my Westbury

bus at the foot of Temple Meads approach at 5-25!! Thank you too for the refreshing interval drink – and all that lovely ice.

Well now – what can I tell you – that there wasn't time in the interval???!

A plume – something like diffused white cloud above the stage set – then funnelling or tapering into a spiral & tailing off up into the flies!!!!!

I couldn't believe my eyes – because when I spotted it I thought 'Where's that smoke coming from?' – looked again & then the general haze curled into this spiral shape – thinned off & disappeared!

I was so disbelieving that I kept looking, but it didn't return – I looked at my watch – so as to be able to 'report' it to you – it was 3-10 – during the first half!

The set is a 'lovely drawing room' with a fairly ornate staircase going 'up' and then 'along'& there are two sorts of pillars left & right – from the audience's view – and this smoke/vapour? Was above the right one!!

Now – there's a thing! – It didn't look frightening – except when I first spotted it, I thought, where's the fire?!! Isn't that strange? I wonder if there was a perfectly simple back stage explanation?
Interesting though, isn't it?

Next visit is 'Arsenic and Old Lace' with a local friend.

I'm intrigued by what I saw & I would quite like to know if it was something 'normal'?! – backstage!

Look forward to seeing you again
Best wishes
Terry B.'

Well, what was seen at this performance?

As you can see by the proliferation of exclamation and question marks, this sighting most certainly disturbed the witness, who is desperately asking to be told that what was seen was normal.

Of course, there was no explanation from backstage; there were no experiments with smoke or any kind of mist effect. There was no fire so there was no smoke and nobody but nobody was smoking back stage and certainly not half way up the stage.

If you put together The Thing and Andy's Stories you will note certain similarities. The spiral shaped smoke/vapour or something and the curling up into itself. The dramatic manifesting in the view of at least three different and separated witnesses certainly adds to its authenticity. When this letter was read to both front of house and back stage crew they all interrupted before the end and said:

'That is definitely the Thing you are talking about.'

It seems that although not so dramatic as these events, quite a few people, on several occasions, have seen smaller or fainter variants of this peculiarity.

I think it safe to assume that some energy form drifts around the Theatre and at opportune moments becomes visible.

In some cases, however, the spiral of mist could herald the materialisation of The Grey Lady.

Whatever it is, at times there is something odd floating around the Theatre.

FESTIVAL PLAY

In June 1963, during a festival play, a Mr K. Hewlit had finished dressing the stage when he heard loud, slow ticking. He then remembered that on stage was a grandfather clock so he made a mental note to see about suppressing the volume of the tick. However, as he was very busy, it slipped his mind until the play was under way. As the play started he remembered the ticking and became puzzled as he had instructions to set the clock at 12.30, the appropriate time for the play's action. He had been informed that the clock had no works in it so it should not have been ticking. If it had been ticking the time would alter and the play spoiled. Ken hurried to the wings to check and was relieved to note that it did not appear to be ticking now. The action of the play reached the part where time was an issue; the actor on cue looked at the clock and declared in ringing tones:

'My God is that the time?'

This he duly did, delivering his lines with gusto.

The clock then struck ponderously and slowly three times.

Dong! Dong! Dong!

All the lights in the Theatre, house, bar, spot, in fact every light source dimmed right down and then became very bright blowing several bulbs before coming back to normal.

The play fell apart, the actor appeared transfixed and remained in the same position for a painfully long time, he tried to speak but his words were jumbled; eventually he looked at the audience, then at the clock and then slowly walked offstage and the curtain came down.

Although the audience were puzzled by this strange behaviour, they were not as shocked and puzzled as the back stage crew were, because they knew that the clock was an empty prop, there were no works in it whatsoever, and it was just an empty box.

But on stage in the middle of a play it struck loudly three times and Mr K. Hewlit is emphatic that the clock was definitely ticking in the afternoon prior to the performance.

The clock apparently was purchased in a job lot of a contents auction from an old farmhouse reputed to be haunted.

TIM'S STORY, DECEMBER 2002

Tim Homewood was finished for the night and went into the Vaults bar to sign off. He was feeling pretty tired having been working in the upstairs VIP lounge, the 1805 Club.

He was about to leave when he realised that he had misplaced his mobile 'phone. Tim looked carefully around but to no avail; it was not down here, so he returned back upstairs.

He searched meticulously the bar area, the kitchen and the restaurant but there was no sign of the 'phone at all. Puzzled, Tim went back to the bar in the Vaults and asked his colleague if he could borrow their 'phone so as to ring his own 'phone to track it down.

After dialling his 'phone number he listened intently; the ringing tone could be plainly heard in the earpiece of the borrowed mobile but no sound of a ringing 'phone could be heard. Tim slowly retraced his route back upstairs; he kept stopping to listen but all was quiet, in fact, it was too quiet.

He now carefully searched the Restaurant, under tables, in the corners, everywhere; there was no 'phone and he couldn't hear it ringing, although the mobile in his hand was giving out a clear ring tone: so why couldn't he hear his lost 'phone ringing anywhere? Tim checked the bar, every shelf, everywhere where a small 'phone could have slid or been dropped. He then went back into the kitchen again, he searched every conceivable place where a 'phone could possibly be, and there was definitely no 'phone anywhere in there.

Tim switched out the light and coming out of the kitchen he locked the door behind him. He was just about to turn away and go back downstairs when there was an almighty bang on the door from inside the kitchen.

The bang was very loud, as if an object had been thrown at the door with some force. Puzzled and a little alarmed as he knew there was no one in the kitchen, Tim unlocked the door again; the kitchen was pitch black so he switched on the light.

He froze as he saw an object on the floor which had been hurled at the door; it was his lost 'phone.

He immediately felt a sense of disbelief and then an overwhelming desire to get away from the area as quick as possible.

He sensed rather than knew there was some malignant presence there. On returning to the Royal Circle someone noticed that Tim's face was as white as a sheet and he looked very agitated. He was asked if he was alright but he replied, 'No not really, I'll tell you later.'

Tim just wanted to get away from the Theatre.

When I was told of this encounter I asked him to tell me about it. He didn't want to, as he didn't like talking about it, but when he did you could see the apprehension on his face as he tried to explain how he felt as he saw his 'phone appear from nowhere and knew it had been flung with some sort of temper or anger by what?

THE SIMULTANEOUS PASSING THROUGH, SEPTEMBER 1996

It was 6.30 p.m. when Steve went into the staff room to get ready for the evening performance; he was in no hurry as he was very early. After changing into his usher's uniform and adjusting his bow tie, he sat down to read the evening paper. Steve read the headlines and then proceeded to do the crossword, and as he was concentrating he heard what sounded like a sigh. It hardly registered with his consciousness and he carried on with the puzzle. Then he heard a faint muffled sobbing. Curious, he got to his feet and listened for the direction of the sound but it stopped. He sat down again but now for some reason he felt uneasy and jumpy. He found it hard to concentrate on the puzzle and found himself listening out for the sound. It was all quiet for a while when he once more heard the sound but it changed from a sobbing into a more of a wail ... then he felt a pricking of fear and the hair on his arms stood up; he stared at the spot from where came the sound, it was coming from the wall in a space between the lockers.

It was 6.30 p.m. and Veronica, a waitress in the Vaults restaurant which was separated by a corridor from the changing room, was checking the tables before the pre show drinkers came in; there was no hurry as she had plenty of time, it would be 7 o'clock before anyone usually came in. She checked the ash trays were clean; this was in the time before smoking was banned in the entire Theatre building. All seemed well and

everything was now ready. The loudspeakers were playing quietly soft, relaxing music, and Veronica felt at peace with the world. Then she heard another sound, it was a sound like a crying kitten and then it went. She wasn't sure as to whether she had heard a separate sound or that it was a hiccup on the tape that was playing, and then once more she heard the sound only louder and spun round to focus on where it was. She suddenly felt apprehensive and her hair began to prickle and she felt a cold chill sweep over her, the sound was coming from the far wall, away from the entrance.

It was 6.30 p.m. and Jacqueline turned on the hot tap of the wash bowl in the ladies' toilet which was separated by two corridors from the vaults, on the opposite side to the changing room.

She was also a waitress in the Vaults but she was refreshing herself in the wash room before the evening rush. She felt very relaxed; she had only been working at the Theatre for three weeks but already loved the atmosphere, everyone appeared friendly and sometimes famous people would attend the bar or have a meal in the restaurant. She felt she was lucky to have got this job as there had been several applicants. She rinsed her face and hands and pulled a paper towel out of the container on the wall, but as she did the sound of the paper pulling out of the holder mingled with a sound like a cat crying. She paused and listened but heard nothing. Jacqueline wiped herself dry then looked in the mirror to check on her appearance; she then heard, very distinctly, a cry getting louder like a kitten in distress. She felt a cold, apprehensive prickle spread over her and she felt afraid; of what she knew not.

Steve stared at the spot from which the sound was coming; from the wall it was a whimpering, crying sound and then he felt a shock of fear as a shadowy shape appeared to slide out of the wall and into the room.

Veronica screamed and backed away as a shadowy shape oozed through the wall and slid into the bar towards her.

Jacqueline's mind blurred with fear as she saw, reflected in the mirror, a smoky figure slide into the wash room behind her.

As Steve watched in horror, the shape manifested into the shape of a little ragamuffin girl with hands to its face and the sound of whimpering crying seemed to come out of his head, he felt swamped in the sound of crying as the strange shape slid across towards the wall near the door.

The crying sound that Veronica heard suddenly magnified as if she had earphones on at full blast; the figure now changing into a small child crying drifted across the bar, and headed for the entrance wall which led to the Stalls corridor. Veronica tried to scream but nothing happened; she was paralysed with fear. The figure reached the wall and passed through as if it wasn't there.

Stalls corridor 6.30 p.m. Alan sauntered down the corridor towards the changing room; he was in no hurry as he was early. He approached the entrance to the vaults and noted that the bar was still closed with the gate across. Then his senses gave a leap as a strange shadowy shape suddenly appeared out of the vaults wall, crossed over the corridor and vanished into the opposite wall accompanied by a strange wailing sound. Alan stopped dead in his tracks, badly shocked, but trying to rationalise what he had just seen; while he was trying to collect his thoughts he suddenly jumped, as a scream rang out from the vaults. Veronica had found her voice.

Jacqueline couldn't believe what she was seeing in the mirror; the shadowy shape materialised into the figure of a scruffy, ragged, female child about nine years old; the

figure was distressed and had its face hidden in its hands as it drifted across the wash room. Jacqueline was aware of the crying sound suddenly upping in volume until it hurt her ears. As the figure approached the line of ladies toilets at the far end of the wash room, it began to shimmer and dramatically change into a triangular shape that suddenly zoomed up and away unto the upper wall and vanished; the sound stopped dead and a deathly silence ensued. It was then Jacqueline's turn to scream.

In the corridor, Alan, shocked by the sound of the scream from the vaults, turned to the entrance to see what he could do when his senses reeled as another scream rent the air, which appeared to come from the stalls corridor, although it sounded a bit muffled. The gate of the vaults slid open and a distressed Veronica came out, badly frightened. Alan asked if she had screamed and why; when she told him he said that he had seen the thing pass through the corridor and that someone else may have seen it as he had heard a scream in the stalls corridor, and as he and Veronica moved to the fire doors connected to the corridor they saw the trembling figure of Jacqueline coming to the fire doors. They all more or less simultaneously said the same sentence.

'My god what the hell was that?'

As they stood there in a state of shock, Steve suddenly appeared; he too was agitated and scared and tried to tell them what had happened but they cut him short by saying that they all had seen the same thing, whatever it was.

What occurred that night has never been explained but subsequently, on occasions, there has been heard in all of these areas by numerous people, both staff and patrons, the sound of a whimpering child. The sound always is accompanied by a feeling of sorrow or upset by the recipient. What it is all about is a mystery, which is good, for what would life be like without the odd mystery?

When the story became known, the geography of the sighting was investigated.

The stalls corridor is curved and is referred to as the horseshoe.

The changing room is near the top of the left side of the shoe, the Vaults bar is in the space in the centre of the shoe and the wash room is at the top of the right hand side of the shoe. If a ruler is taken and placed in the changing room, the vaults, the entrance corridor and the wash room they are all in a straight line. This entity moved in a dead straight line passing through all the sighting areas, which adds to the puzzle. Where was it going and where had it come from?

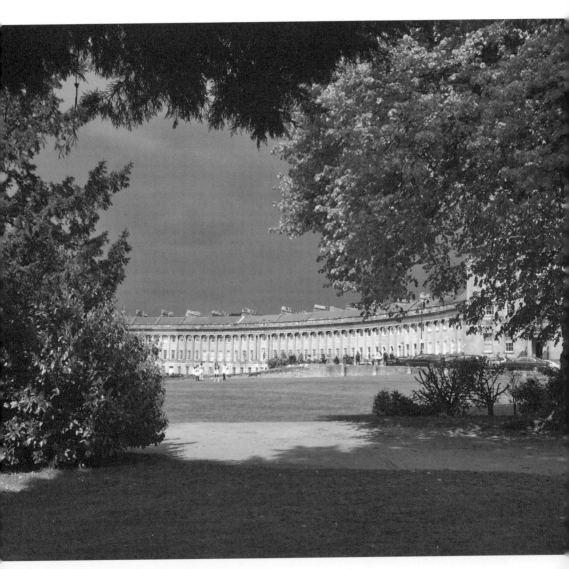

The Royal Crescent, Bath.

THE GREY LADY

INTRODUCTION

The principal ghost of the Theatre Royal is of course The Grey Lady. Her appearance is usually accompanied by the strong scent of jasmine. She wears an eighteenth-century style evening dress and wears some sort of feather plumage in her hair. She has virtually no colour, although she is sometimes seen with a faint green haze but the whole figure, clothes, face and hair appear as a drab grey. At times she appears solid although sometimes as a wispy, smoky figure.

There are two versions of her death. One is that she hung herself in the Garrick's Head, due to unrequited love for an actor in the Theatre Royal.

The second version is that she was having an affair and her husband killed her lover in a duel. In her grief and horror at the shock of her lover dying in a duel, she rushed hysterically to the roof where she either jumped, or fell to her death.

The Grey Lady's costume is in the fashion of the eighteenth century, long before the Theatre and the Garricks existed (c. 1805).

There could of course have been two deaths; one in the eighteenth century and one in the nineteenth. So, maybe there are two ghosts.

No matter what the origin of the ghost or ghosts, the fact is that there is a haunting. The Grey Lady or ladies, haunt the old house of Beau Nash, which is now, although physically attached, separated into the Garrick's Head and the Theatre.

The ghostly vision of the apparition/s must still appear as it was in the time of Beau Nash. His house was the scene of many traumatic events; apart from the fact that some guests won or lost fortunes in the gambling atmosphere of Bath in the eighteenth century, there was also the death of possibly two ladies and the duel to the death, so it's no surprise that the Garrick's Head also has its fair share of alarming happenings.

The Grey Lady's favourite haunt in the Theatre is in the top left-hand box facing the stage, although she has appeared in the opposite box. She also drifts down the stairs from the box into the Stalls area and around the seats in the Stalls auditorium, sometimes diagonally through the seats (physically impossible.)

At times she has been seen in the corridor of the upper circle; on occasions, her presence is made known without her becoming visible. Doors will open, cold draughts will occur, accompanied by the scent of Jasmine and an overwhelming awareness of a presence passing close by. These events are now known as a 'Passing'; I was once a witness to this strange phenomenon.

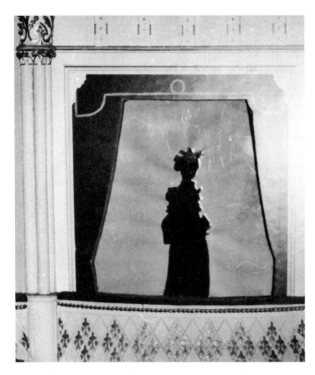

The Grey Lady.

She falls into the class of a harmless ghost, for she does not seem aware of any of the witnesses that have seen her. She is observed standing (she does not sit when in the box.)

Why does she haunt the top left-hand box facing stage in the Theatre? The answer came to light when some old maps were matched with the modern structure, and her bedroom superimposed itself on the location of the top left-hand box.

Therefore The Grey Lady is walking her old bedroom, which is now a box in a live Theatre.

The most predominant sighting in the Garrick's Head is in the right side bar, which was Beau's drawing room.

Let us move forward and meet the The Grey Lady.

THE DAME OF SARK

This rather startling Grey Lady story illustrates the link between the Garrick's Head and the Theatre.

Since 1805 when the Theatre was established in part of the building and the Garricks took another part, the ghost known as The Grey Lady haunts the two buildings.

Her main haunt in the Garrick's Head is in the right-hand bar as you enter. The main haunt in the Theatre is the top left-hand box facing stage.

The reason for this is the fact that the ghost is haunting the old house of Beau Nash.

She appears in the drawing room which is now the right bar in the Garricks; she appears in her own bedroom which is now the top left-hand box in the Theatre.

Her visits to the Garrick's Head are preceded by Jasmine perfume and most of the sightings take place in February. However, in 1975, February came and went with no Jasmine and no sightings. The rest of the year passed with nothing untoward happening at all, until August. In August a play came to Bath called the *The Dame of Sark*, a story of the German Occupation of the Channel Isles in the Second World War.

On 23 August 1975 the play was under way and the tension of the plot heightened. A male member of the cast finished his part of the act and strode off the stage in a temper, and he tracked down Norman Wooton, the stage manager, to complain.

He was angry because, at a critical part of the play, he noticed a lady in the top left-hand box turn and leave, proceeding down the corridor to the rear of the upper circle. As this distracted him he was sure it must have distracted the audience, because she was dressed oddly.

Norman asked how she was dressed, only to be told that she had on a long grey dress with bustle and appeared to have a feather plume in her hair. Norman felt a chill at this description, but during the interval he went to check out who was in the box.

It had not been booked and no one should have been in it. Norman then went towards it to see if anyone was cheating and sitting there without a ticket. As he passed two usherettes, who were new to the job, he enquired as to whether they had seen anyone moving about from the box during the first half? They both said no, they hadn't, but said that an icy, perfumed draught had made them both shudder. Later on, the perfume was recognised as jasmine. With all this information, Norman knew it was no good looking in the box.

The bells signalling the end of the interval rang out, so he turned to leave, when someone said to him that there were two girls in the stalls trying to get his attention.

Looking over the balcony drop he saw two young ladies in their late teens or early twenties waving a program at him and asking an inaudible question. By using sign language he pointed to his watch, shrugged his shoulders apologetically, and raced backstage to ensure a clean start to act two.

It was time, the curtain lifted and the opening scene of act two was about to start when...

On stage, what looked like a swirling pillar of smoke, appeared right next to Dame Anna Neagle, who, horrified but still keeping her composure, did a graceful side-step away from this strange occurrence. Then, to add to the surreal effect, the smoke solidified into a lady in period costume with no colour; it was The Grey Lady appearing in full view of 857 witnesses. How many witnesses do you need to prove a ghost sighting?

There was a scream from the stalls and one of the two young girls that had tried to attract Norman's attention half stood up and then fell down in a faint.

Four members of the cast took one look at this happening and walked off stage, leaving the Theatre and not coming back. They sent for their belongings later.

The Grey Lady then began to move; she appeared to start sliding or drifting diagonally across the stage without moving her feet, but became fainter and fainter as she moved; she then vanished in the area of the wings.

The curtain came down on a bemused audience, although some of the regulars were climbing over the backs of some seats to get out.

Understudies were hurriedly instated and Anna Neagle, being the trouper she was, stuck it out for the rest of the week. However, she swore that she would never set foot in the Theatre again. She kept to her word; if she came back on circuit she stayed in the hotel and understudies played her part.

The two girls in the stalls were on holiday from Canada, and their story is related under the title 'The Canadians'.

A similar appearance occurred in the early 1990s. This was a play called *A Moment of Weakness*, although The Grey Lady did not appear on stage she materialised in the box and was witnessed by the stars of the play, namely Liza Goddard and Christopher Timothy.

The earliest sighting was back in the 1920s when she once again appeared in the box and was seen by Pavlova.

OUT OF THE MOUTHS OF BABES

Miss 'R' was young, pretty, and full of fun and adventure. She had long, dark hair and sparkling blue eyes. She was a picture to look at, but at times could be a real nuisance; well, after all she was only five years old. Accompanied by her father, she skipped into the Theatre. Her father 'M' had not really intended to go to the Theatre this lunchtime, but he was staff and he was passing, so like all the staff he couldn't resist popping in.

Derek, the bar manager had just opened up, so drawing a half pint for himself and 'M', they settled down to the usual chat about the Theatre which never appeared to bore the staff. Miss 'R' wandered around looking at the pictures hung on the walls. After a few minutes she became bored with her present surroundings and went out into the Dress Circle (now the Royal Circle) corridor. On seeing her leave 'M' called out for her not to stray too far, then resumed his chat with Derek. Miss 'R' explored the wonderful mysteries of an empty Theatre. Going in the Dress Circle auditorium she played at sitting in different seats. She was happily engaged in this world of imagination when something attracted her attention. What she saw made her eyes open wide with surprise. She was fascinated by what she was looking at and transfixed she walked slowly towards it.

Ten minutes later, thinking he had spent as much time in the Theatre as he should, 'M' took his leave from Derek and went looking for his daughter. He walked into the corridor and not seeing her, called her name. Receiving no reply he called again. The Theatre was still and very, very quiet; no answer came to him. Getting a little anxious, he shouted louder. There was still no reply. Getting alarmed, he opened the door to the auditorium of the Dress Circle and went in. Then he heard his daughter's voice; she was stood at the front of the circle, looking up towards the top left-hand box and she was talking. 'M' followed her gaze and noted that the box she was talking to was empty. Now a little angry as well as relieved, he called sharply to Miss R that she should come when called and right now please. Little Miss R still stood staring at the top box, fascinated.

'Rachael', bellowed 'M'.

She turned round, startled, as this last shout penetrated her consciousness. With one more look at the box she turned and came to her father.

'What on earth are you playing at?' he asked.

'I was talking to the funny lady,' said 'Rachael'.

'What funny lady?'

'That lady, in the window', she said, pointing to the box.

Looking at the box again 'M' saw that as far as he could see the box was completely empty.

'I see you were talking to a cleaner?'

'No' said Miss 'R', with all the firm seriousness of an indignant five year old, who thinks that grownups and, especially daddies, could sometimes be downright stupid. 'She was a real lady with jewels and a dress and she smelt nice.'

Knowing the stories connected with the top left-hand box facing stage, M's hair stood up on the back of his neck. His only thought now was to move away from this part of the Theatre and stop his daughter having conversations with someone unseen.

'Now come on it's time to go and it was a cleaner in the box.'

Going forward he grabbed her hand and dragged his protesting daughter out of the auditorium towards the foyer entrance. As they cleared the door of the Theatre and stepped outside, Miss R suddenly stopped dead in her tracks. She dug her heels in and adopted the posture feared by most parents. She placed her hands on her hips and bent forward slightly, the sign of an aggressive and furious six year old.

'Daddy, it wasn't a cleaner, it was a real pretty lady who smelt nice, and, and daddy, she was all puddly!'

'She was all what?'

'Puddly, she was all puddly.'

He couldn't understand what puddly was and she couldn't explain what she meant, so for a while the meaning of the word was lost. As the days passed he gave a lot of thought to what had occurred in the Theatre that morning. His daughter's description of the person she thought she had seen gave him a cold prickle, because she had described The Grey Lady in detail, except for that strange word puddly; peculiar that this word puzzled him.

A fortnight later it was his birthday and he had been given a cigar. He was not used to cigars and had difficulty in lighting it. Eventually the end burst into flame and thick black clouds of acrid smoke billowed about him. His daughter, who was sat on the far end of the settee, was enveloped in this dense cloud of smoke and reacted by waving her arms and wafting the smoke away. Angrily, she turned to her father and said, 'Daddy, please don't put that puddly stuff all over me.'

He went cold, there was the answer, and there was the meaning. His daughter had described in detail The Grey Lady; she had been puddly, a bit smoky, and not quite real.

SALLY

Sally walked close to the side of Sid Payne as he made his security checks of the Theatre. Sally loved Sid very much and she would protect him from any trouble that might arise during Sid's tour of the darkened Theatre. The show was now over and the Theatre was empty apart from Sid and Sally.

Sid was very pleased of Sally's company this night, as earlier in the evening performance there had been a dramatic event on stage. The Grey Lady had actually appeared on stage next to Anna Neagle as she performed in the *Dame of Sark*.

Two young girls in the audience had been treated by the St John's Ambulance people as one of them had passed out on witnessing this occurrence.

The atmosphere in the Theatre this night was very tense. There seemed to be subtle movements in all the shadows and whispering sounds appeared to emanate from the dark corners.

However, as Sally appeared not in the least perturbed and as animals are supposed to sense these things, he felt a bit more relaxed. He also knew that if there were any trouble, Sally would reveal the wolf instincts that lurked deep in her soul. They had just cleared the Lower Circle, and were now checking the Foyer and entrance doors. Satisfied that all was secure, they headed for the Upper Circle. Sally sensed that Sid was nervous, so being the faithful female that she was, she walked very close to his side. For, after all, he was her master, and she was a very obedient Alsatian bitch.

Now the Theatre was dim and empty, except for Sid and Sally, or was it? Sid walked into the Upper Circle corridor, calling Sally, who had stopped to investigate a rather interesting smell near the toilet door. On hearing Sid's voice, she bounded into the corridor with eyes shining, ears alert and tail wagging. She trotted proudly down the corridor with Sid until he went through the door of the auditorium to check inside. As Sid passed through the door, Sally, who had been about to follow him, stopped dead in her tracks. Her ears flattened to her head and she backed away from the door, growling ominously.

'Sal,' queried Sid, 'what's up lass?'

Sally began to retreat slowly backwards away from the door, and began whining.

Sid immediately became nervous as he saw his fearless dog transform into a very frightened animal. Asserting his common sense, Sid tried to bring back reality to a scene that was fast turning bizarre.

'Now come on lass', he said.

He went up to the agitated animal and, gently pulling on her collar, he tried to tug her through the door. The closer he got the more she protested. Sally dug her heels in and tried to back pedal away from the door. She also twisted her head in an effort to pull away.

Sid then suddenly went behind her and gave her an almighty push through the door. The result was startling.

Where Sally lost her reason.

As Sally passed into the auditorium she let out a terrible howl, and barked furiously at something amongst the seating in the Upper Circle (Dress Circle).

For a fraction of a second Sid saw a faint, dark form about 18 inches long; it was in the shape of a triangle that appeared to turn into itself and disappear. The effect on Sally was electrifying.

As Sid backed away Sally, his faithful and loyal companion, flew for him.

Sid staggered back in terror as a crazed animal with eyes flaring, hackles raised and jowls set in a ferocious snarl suddenly sank its fangs deep in his arm with all the strength and fury of her wolves' ancestry. Sally, the gentle loving dog, turned on her master and savaged him.

Sid tried desperately to push the snapping jaws away from his throat. The animal was completely demented and with savage growls it strove to rip out the life of its beloved master.

They rolled on the floor locked together in what was definitely a fight to the death.

Sid knew he was in a life or death situation and with all his might he heaved at the writhing dog's body and they both tumbled out of the auditorium and fell on the corridor floor. As they cleared the doorway the sprung door closed. As the door shut the terrible snarls of Sally died away, and she changed once more into a very frightened and confused animal.

Whining pathetically she tried to lick Sid as if to say sorry for what she had done. Climbing shakily to his feet, Sid looked at his trembling companion and with a curse he pushed at the door to make sure it was shut, and then sat down to regain his composure. Sid just sat trembling and Sally was a picture of dejection, whining loudly, and with drooping head and tail between her legs, she just kept trying to lick Sid.

About ten minutes passed before a badly shocked Sid and a badly frightened Sally walked slowly down the passageway, away from whatever it was that lurked in the Circle that night.

Later on, Sally still did the rounds with Sid and was quite happy to wander anywhere in the Theatre except the Upper Circle. Under no circumstances would she go anywhere near it. If she had to pass the auditorium door, she would slink past on the far side of the corridor with her ears flat and a soft growl in her throat.

What strange being skulking in the shadows of the auditorium could have changed this friendly dog into a raging beast? Sally can't talk, so we will never know what the poor animal experienced that fateful night. Whatever it was it most certainly wasn't friendly.

THE CANADIANS

Molly, the manageress of the Upper Circle bar, had just finished collecting the glasses after the interval of this night's performance of the *Dame of Sark* on 23 August 1975. Molly suddenly spun round startled as the door crashed open and a very agitated young girl rushed into the bar shouting:

'Quick, is there a first aid lady here?' cried the distraught young lady.

'Whatever's the matter?' asked Molly.

'My friend, she's passed out, we've seen it, we've seen it', the young woman screamed in a voice edged with panic.

'Seen what for goodness sake?' said Molly.

'Have you got a first aid lady?' yelled the girl again.

'Oh dear, yes, yes there is, but she's usually on the floor below in the stalls', said Molly.

'No, they sent us up here because she moved tonight.'

'But what's wrong, have you hurt yourself?'

'No, it's not me, it's my friend, she's passed out.'

'Oh dear, don't worry, I'll get them for you.'

'Please hurry.'

'Alright, alright I'll get her for you.'

Molly hurried to the door noting that the girl spoke in a strong Canadian accent. As she returned with the ever faithful St John's, she saw that the other girl was being carried unconscious into the bar by two young men.

The first girl was obviously made of stronger stuff and was fast recovering her composure. Molly was very curious as to what the girl could have seen that had sent her into a panic and caused her friend to pass out.

'Now then dear, what actually happened?' she asked.

The girl watched as the ambulance attendants tried to revive her unfortunate companion. It was a few moments before she answered Molly's question. Then, as she saw signs of life returning to her friend, she took Molly to one side and spoke in a low voice.

'I know you won't believe me but this is what happened. In the interval my friend and I were sat in the stalls, we had enjoyed the first act and were just sat relaxing, reading our programs when my friend grabbed my arm real tight, you know, real tight. Well when I looked at her she was in an awful state.'

'Oh dear', said Molly.

'Yes, she was trembling and looked scared to death.'

'Really?' said Molly.

'True, she was really scared you know. Well I looked to see what had scared her.'

'Of course.'

'True, well I looked where she was looking, up at that box, at the end you know.'

'Oh yes', Molly affirmed, realising what might be coming.

'Well at first I couldn't see anything at all, you know. Then, oh, you're not going to believe this I know.'

'No, you're alright, I'm listening, carry on.'

'Look this may sound strange to you, but we saw a ghost!'

'Oh dear.'

'I said you wouldn't believe it, didn't I.'

'I didn't say that, you carry on dear', Molly replied.

'Well alright. It really happened you know. As I was saying, at first I couldn't see anything, then I realised I could see the figure of a woman.'

'Oh, a woman you say.'

'True, she wasn't very clear but it was a woman, but she looked a bit hazy and appeared to be in a green sort of mist, I thought it was some stage trick or something, and then someone said the manager was above us. We waved our programs at him to ask what the effect was for, but he had to go to start up act two.'

'Oh, that would be Norman.'

'Sorry?'

'Never mind, carry on.'

'Well although the lady was still in the box, the curtain rose for the second act when something awful happened.'

'What, for goodness sake?'

'The lady in the box dissolved into spinning smoke and reappeared as smoke on stage were she changed into this lady in period dress. Then as I watched her she, she, oh you're not going to believe this!'

'You go on dear.'

'OK, well, you listen, as I watched that woman, she moved sideways and then she vanished.'

'Vanished?'

'Vanished. Poof! Just like that. God I don't believe it myself now. But it did happen, it did, I saw it.'

'Goodness gracious.'

'Oh dear, you don't believe me, do you?' said the girl.

'As a matter of fact I do', replied Molly. 'You see that ghost has been seen before and in the exact spot that you said.'

'Really, you mean really, oh this can't be true. Really, wow, can you believe that.'

'You'll have to now, won't you', said Molly. 'Can you describe her at all?'

'What? Oh yes. Really it was a real ghost? You mean that.'

'Yes, can you describe it, her, the ghost?'

'Yeah, she was real weird you know, like a movie ghost, you know all sort of misty and a dirty white colour with a slight touch of green.'

'Grey?' said Molly.

'Yeah, grey, that's it, you know like all over.'

'And she vanished?'

'Yeah, truly, she just wasn't there any more, she just switched out like a light, that's when she passed out', the girl said, indicating her friend who was just on the point of regaining consciousness.

When her friend did come round she verified everything that had been said. They were not aware of any perfume and could not recall any small details.

The convincing factor in this story is that they were visitors to Bath from far off Canada, and had no prior knowledge of the Theatre's reputation, and this coupled with the fact that the happening caused one of them to faint. What they did see fits very neatly into the pattern of The Grey Lady. There is little doubt that she did indeed walk that night.

As regards strangers to the Theatre, the story 'The Australian' is a classic and very convincing as it happened in late 1999 just before the millennium in 2000.

SUE MARTIN'S ENCOUNTER

On Friday night, 26 October 1998, at about 9.45 p.m. a 'phone began to ring. Sue Martin, the usherette on the stalls level, moved forward and looked through a glass panel were she saw the ringing 'phone on a table. She saw a woman hurry over and pick up the 'phone. As the woman began to talk a curtain near the window suddenly whipped to one side, a man pounced on the woman's back, wrapping a knotted cord around her neck, and although she struggled violently, he began to strangle her. Sue

turned away, back into the corridor, feeling very uneasy as the sinister action of the play *Dial M for Murder* continued in the auditorium.

Although the menacing atmosphere of the play affected the area outside the auditorium tonight, for some reason, Sue felt even more apprehensive than usual. Her work colleague Nick had also stated that it felt very creepy down in the stalls tonight. Nick had now gone upstairs to the dress circle for a while. When he left Sue felt suddenly very vulnerable. She was aware of an oppressive atmosphere, and although she felt lonely because Nick had gone she also felt not entirely alone. Sue shrugged off the sensation as her active imagination and went back to the viewing window in the auditorium doors to watch the progress of the play.

Later on, Sue was horrified to feel a sensation like static electricity behind her and she instinctively knew from past experience that something eerie was in the close vicinity. Something fearful was on the move and whatever it was Sue sensed it was approaching. No, no! She thought it is all in my mind; it's the play playing tricks on me.

She therefore steeled herself to watch the play and concentrate on the normality of her surroundings. There were the chains to collect from the Royal Circle, there was the odd ice cream carton to place in the bins and she had to ensure all doors were open at curtain fall, and hopefully Nick would be back in time to help. Everything would be alright when the public filled the area. Sue began to relax, the show would be over soon and she would be climbing on her pride and joy, her new motorbike and be on her way home.

Sue then shuddered, the prickling sensation suddenly grew stronger and she knew that whatever it was, it was descending the stairs from the area of the Royal Circle to the left of Sue. Her heart began to pound and a kind of numbness swept over her she sensed rather than heard the rustle of material. Sue half turned to her left to see if there really was anything or anybody coming down the stairs, hoping of course that there would be nothing there. As Sue turned she felt a paralysing shock to her system, and she was aware of taking a sharp intake of breath.

Into her vision swept a shape, which was passing behind her, it was only in vision for a fraction of a second and then it passed completely behind her. It was a grey, shadowy figure wearing a dress of period costume with a bustle that slid silently past her heading down the horseshoe corridor.

Sue was so stunned by what she saw that she froze and did not turn completely round to follow the progress of the apparition; fear preventing her from seeing more.

A few seconds later the spell broke and Sue obeyed the body's instinct and ran as fast as she could up towards the Foyer. The staff on duty in the Vaults bar were startled by the sight of Sue running at full speed past the entrance making gasping sounds; they all knew from her appearance and manner that something strange had occurred. As Sue reached the foyer she saw Nick, and blurted out to him what she had seen and asked him to come back with her.

They both cautiously returned back to the area; however, as Nick came as far as the ladies toilet, he suddenly exclaimed:

'My god I can feel it.'

He shuddered physically and stated quite bluntly that he was sorry but he wasn't going to stay down here anymore, and swiftly departed back up the stairs, leaving Sue once more alone with her fears.

Although still apprehensive she felt that the atmosphere had subtly changed. All now appeared normal.

Eventually the show ended and the public poured into the corridors, which put everything back into perspective.

Sue climbed on her motorbike and sped home, thankful for the normality of life once more.

She is rather proud of the fact that she has joined the ranks of the many witnesses to the reality of the 'Grey Lady.'

Shortly after this event Nick left his job at the Theatre.

THE AUSTRALIAN

Matinée performance 2.30 p.m. September 29th 1999

This was a double black comedy bill, and as luck or fate would have it, I was in the Theatre that afternoon. The show had finished and I was helping to pick up the debris left by the patrons after the show. I was just about to leave when John Butler, the front of house manager, came into the auditorium and said:

'Oh Malcolm, I'm so glad you're still here, I have here a young lady who wishes to speak with you.'

With that, an extremely attractive, dark-haired young lady approached me.

'Are you Malcolm?' she asked

'Yes', I replied.

'I have been told to speak to you, would you answer a few questions?'

'Sure, fire away.'

'Is this Theatre haunted?'

'Well, you could say that.'

'Is it a lady?'

'Er, yes.'

'Is it a Grey Lady?'

'Erm, yes.'

'I saw her this afternoon.'

'Oh yes,' I said, disbelieving.

'Before I go any further may I tell you that I am clairvoyant and...' she said, handing me a plane ticket, '...this affirms that I landed at Heathrow this morning from Australia. I then caught a train to Bath arriving about lunchtime, after booking into my hotel I looked around for something to do and came across this beautiful Theatre. I saw there was a matinée performance so I bought a ticket in the stalls to watch the show. During the first half I was aware of a figure drifting down the aisle towards me on my left. At first I thought it was someone going to the toilet but I then became aware that this figure was paranormal, a ghost, the closer it got the more I knew this was an apparition. It passed behind me and went to the far side of the auditorium, but as I found later that this was impossible, because she went behind me and crossed to the other aisle but she remained on the same level and after the show I checked and saw that to cross from one aisle to another entails going down a short staircase, crossing over and climbing a second staircase to get to the same level. But she kept going purely horizontally as if on a flat level I also got a strong sense of her and knew her name was Sarah. I also sensed she was displeased. Then came the interval and I pondered at what I should do about

what I had seen when she reappeared. 'Now,' she said, looking at me, 'does she like to be up there?' sweeping her arm up and pointing straight at the left-hand top box.

'Well yes, she does', I replied.

'I thought so, she looked and I sensed she was happy up there, so you know about her, do you?'

'Very much so, you have described our grey lady to a T and pointed out her usual haunting habitat. Brilliant.'

'I am pleased about that; did you know her name was Sarah?'

'No. This I did not know.'

'She is about, isn't she?'

Another voice cut in the conversation, as Sue Martin came into the stalls. Sue was talking straight to me.

'She is here, isn't she? I can feel she is here.'

'You're dead right Sue, this lady here saw her this afternoon and she is clairvoyant.'

'I knew it; I have had the same feeling I had when she walked past me last year.'

Stories were exchanged about sensations and sightings of The Grey Lady; at the end of which, this lady, who is called Melanie, and I exchanged email addresses and will keep in touch. To conclude this story, I believe that what has happened to so many people from different backgrounds and far flung geographical locations rules out collusion and conspiracy.

Although I was convinced before, this story really hammered home the true existence of this well-sighted ghost.

JACKIE GREENSLADE'S STORY, 1996

Jackie fished around in the washing bowl and pulled out the last glass. The interval on the Upper Circle had been quite busy, and there had been a lot of washing up for her to do. Jackie was alone in the bar, but her colleague was in the corridor tidying up.

Denise from the stockroom was also in the vicinity. The second half of the show was now well under way, so there would be no more customers. Jackie finished polishing the glass and after placing it back on the shelf she began to wipe down the bar counter. She glanced around the bar to check for more glasses.

The doors to the auditorium were now closed, although one could still see into the corridor as the top half of the doors were plain glass. Suddenly, a small figure appeared passing the doors to the auditorium. Jackie saw quite plainly a small figure, with a cape and hood with a lovely silvery, grey sheen, slide past the windows of the doors.

The last thing on Jackie's mind was ghosts; she just assumed that it was a patron leaving the show and going out early. Jackie did wonder why this person was leaving so early and was curious as to the clothes she wore, so Jackie kept an eye on the side door, which was the only way out of the corridor. She did this mainly to check out the apparel worn by this small or stooped female figure. She waited in vain but no one passed the side door. Well, that's strange, thought Jackie, and went out into the corridor to check why this figure had stopped. There was no one in the corridor except her friend, who was tidying up the corridor shelves.

'Where did she go?' asked Jackie.

'Who?' replied her friend.

'I just saw a lady in a cape and hood pass the doors on her way out, you must have seen her.'

'What? No. No one, but no one, has passed through here, and I have been here all the time.'

The door of the stockroom was open and Denise was taking in the returned ice cream boxes. Jackie called to her and asked if she had seen anybody coming past in the last few minutes. No one had come down the corridor since the curtain had risen and she had been stood near the open door all this time. Denise then asked why?

When Jackie described what she had seen, Denise promptly told her:

'Good God, I think you have seen The Grey Lady.'

Then Jackie recalled the strange silver grey hue of the cloak worn by the figure, she wondered why it hadn't registered with her at the time that it might have been The Grey Lady. However, she is a practical person, not given to flights of fancy. Jackie's immediate reaction had been the logical one; she had witnessed someone leaving early, wearing odd clothes of a peculiar silver grey colour. Strange though, she thought, where was the smell of Jasmine that usually accompanied sightings of The Grey Lady?

A few shifts later working on the floor above (the Grand Circle), as she was talking to her work companion behind the bar, she was aware of the scent of jasmine. Before she

Witness Jackie's letter.

could say anything her friend asked her what perfume she was wearing as it was quite a heavy scented smell, which she subsequently recognised as jasmine.

Shortly after that, back in the Upper Circle bar, one of the bar doors she had just pinned back released itself and closed. This was the same door where she had seen The Grey Lady pass a few nights previously. Annoyed but a trifle apprehensive, she once more pinned back the door; however, as she walked to the bar she heard a ping and the catch released the door again.

Jackie was now getting a little alarmed and was sure she could detect a faint smell of jasmine; The Grey Lady appeared to be singling her out for some reason. Jackie tried several times to pin back the door, but to no avail; the door refused to stay pinned back. Jackie sent down for Malcolm, the usher in the stalls, who was an investigator of the paranormal.

Malcolm, sensing a mischievous presence, pinned back the door, gave The Grey Lady or whatever presence was there a few choice words, and warned to leave Jackie alone. The doors remained pinned back and did not close of their own accord again.

When Jackie is questioned about these phenomena her comment is usually:

'Very strange, very odd, very odd indeed, very odd.'

Jackie Greenslade's and Malcolm Cadey's accounts have been investigated and portrayed in a TV documentary called *The Why Files*.

THE PASSING

'My god! What's wrong with the wall?' the shrill cry of a young woman seated by the Lower Circle Bar rang out. The young woman, a member of the house staff, half rose to her feet and pointed to the wall near to the door side of the bar. Her work colleagues, who were sat at the table, turned, startled at her outburst and looked at the wall.

It was about 11.15 p.m. The show was over, but as usual nobody wanted to go home. Members of the staff and cast stayed on to drink and, of course, to talk shop.

The bar was quite full and a loud buzz of conversation filled the room. The cry of the young woman in the corner passed unnoticed by the rest of the crowd.

Her companions stared at the wall she had indicated. They were horrified to see it apparently shimmer and ripple as if momentarily it had turned fluid, or as if it was viewed through a heat haze. It was like this for about ten seconds then the wall appeared normal again. Then the haze started again only fainter, and it took the distinct shape of a lady in a period costume dress, then it vanished again, followed by a rush of cold air with a scent of perfume.

In a straight line from the wall right across the bar's width to the double doors leading to the Lower Circle corridor, a strange thing happened. Everyone that stood in that path, suddenly spun round, as each in turn felt something rush past them.

Keith Pass, a backstage technician, happened to be stood close to the doors. He felt a cold wind rush pass him and to his alarm the two doors to the corridor suddenly swung wide open, as if an unseen body had run through them. The loud chatter in the bar suddenly stopped. No one spoke and the bar became silent as everyone became aware that something strange had happened, but what?

A few seconds later the doors swung open again and everybody jumped, only this time it was a perfectly normal young girl from the cast coming in late for the get together. However, she was in a very agitated state and asked no one in particular:

'What the hell just passed me in the corridor?'

As she had approached the bar a chill wind smelling of a pungent perfume had swept past her.

The scent was never verified, but everyone was certain that it was Jasmine.

The fact remains that whether it was The Grey Lady or not something definitely happened that night.

How can I be so sure?

I was one of the people sat at the table that night. I witnessed everything.

CONCLUSIONS

That concludes the Theatre stories so far, no doubt there will be plenty more. However, although the Theatre abounds with activity it is not the sole source of paranormal activity because the city of Bath also has its fair share of oddities.

POPJOY'S

Next door to the Theatre is the Strada restaurant, which used to be called Popjoy's, named after Beau Nash's last mistress who was called Juliana Popjoy.

This was Beau Nash's last home until his death in 1761.

When Beau Nash died Juliana did a strange thing; she left the security of this fine home and went to a village called Bishopstrow, about 12 miles away.

She actually lived in a hollowed out Oak tree and grew herbs and plants for a living, eventually growing old, and senile, tottering around the village dressed in rags, where eventually she collapsed and died on a doorstep. Some stories say it was the doorway of Popjoy's restaurant, but some say it was the doorway of her old home.

However, this ghost story occurred in 1975 in exactly the same time zone of the sighting of The Grey Lady on the stage at the next door Theatre.

A traveller came to Bath and he was too late to get the evening meal at his hotel. He was told to come to Popjoy's restaurant. He ordered a very unusual and expensive meal and took a drink upstairs to the lounge to await its preparation. About four minutes later the staff heard a yell of alarm upstairs and the man rushed down the stairs in a panic, ran outside, jumped into his car and whoosh, he had gone.

Now they were preparing his meal, and they were unhappy that they would lose out on payment. They found out from a waitress where he was staying and rang the hotel and asked to speak with this man.

'Sorry', they said 'he just rushed in and checked out, shouting that he was leaving Bath and never coming back'.

'Well didn't he say anything about why?' they asked, and this is his story.

'I went to that Popjoy's place you said to go to, and after ordering a meal I went up to that funny old fashioned lounge. It was empty so I crossed the floor to sit on the green settee at the far end, as I was about to sit I was aware that a lady of importance dressed in evening robe, jewellery and perfume was stood in the middle of the room.

She was not there when I walked to the corner and I was surprised to see her there, but to be polite I smiled at her.

She did not smile back; she stared at me with a hostile look as if I had no right to be there.

Being embarrassed I sat down looking at my drink, when I looked up, she was sat next to me, I did not see her cross the floor and she hadn't time to do this anyway.

I was now very alarmed and turned to her to seek an explanation, as I turned she began to turn towards me, but as she moved she began to shimmer, her image blurred and she suddenly changed from well dressed lady, with robe, jewellery and perfume into a wizened old lady dressed in rags, and that is why I left there and I am leaving Bath.'

Just for the record the lounge upstairs was in modern décor, not old fashioned.

The Why Files interviewed the Manager of Popjoy's and during the interview a tape recorder kept rewinding itself every time the name Beau Nash was mentioned.

A waiter coming down the stairs made a joke about this story when his bow tie tightened against his throat and then unravelled and flew up the stairs.

TRIM STREET

In 1980, a Mrs Verone reported that she had seen an apparition in Trim Street, and when questioned about her encounter it emerged that she was alone and there were no other witnesses with her.

Then the same event would be portrayed by other people from all walks of life and countries. The sighting reports were all identical.

'I was walking down Trim Street from Barton Street towards the Archway on the left. As I came near to the arch a figure suddenly emerged and he walked swiftly towards me then crossed my path going to the far side of the road.

The sudden appearance startled me as he was dressed in Victorian evening dress, with a long black cloak and top hat. As he crossed the road I was curious to see what all this was about and I tried to turn around and look at him. To my surprise I could not turn my head and I couldn't stop walking, I also felt a sinking sensation in my stomach as I knew that this was unreal.

Suddenly the spell was broken and I spun round to see this strange figure. As I turned I felt a stab of fear because the street was completely empty and there was no time for him to have left the street or turn into a doorway. He had, without any doubt vanished.'

The strange thing about this sighting is that the witness is always alone when it appears.

GRAVEL WALK AND THE DELL

Gravel Walk is a public footbath in Victoria Park leading up to the Royal Crescent which has numerous sightings of a ghost. Known as the Dark Regency man, he is mainly seen walking towards the steps at the entrance, but on occasions appears to shadow people walking from the Royal Crescent.

There follows a letter to myself of one such worried witness.

'Dear Sir/Madam,

I am writing to let you know about an experience I had one morning in Bath...

I was a resident of the city for 30 years and it was while on my way to work early one morning I had my experience. It was September 1994 at about 6.30 a.m., I walked from the Circus to the Royal Cresent and then down the gravel path beside the Crescent. I saw between the trees a figure on the path that runs parallel with the crescent green, I was viewing the figure from behind as he had his back to the Crescent and about a quarter of the way along the path, he looked dark and quite solid. I could see him the whole time I walked along the gravel path, as I got level with the parallel path and the figure I could see he had not moved and still had his back to the Crescent. I stopped for a few seconds and looked at him, this giving me a side view of the figure, he was solid as I said, dark, long dark cloak, Quaker type hat, I could not see his feet as the cloak came to the ground and he was shimmering, like looking at something through a heat haze. As I walked forward to the road I saw he also walked forward at the same time...he would have walked through the trees and bushes to come out on the road but there was nobody there, I looked up and down the road and towards the bushes where he would have been but there was nothing. Now I know of the man in black and that he haunts savil row and assembly rooms but I feel this could also be the same man... spirits can go anywhere and at any time, so why not here??

If you can shed any light or have other sightings from the same area I would be very interested.

With Regards

Alan W. Bur

Just off to the side of Gravel Walk is a haunted area known as the Dell where the Ghost Walks of Bath Tour introduce people to the reality of the supernormal. Here is a testimonial from an American girl, who still keeps in touch by email.

DIANA'S STORY, 1995 (AMERICAN)

I looked forward to the promised contact with the supernormal, but did not get the usual expected sensation such as a tingle or buzzing, I felt a bit disappointed and turned to come out, but as I did my left shoulder suddenly went icy cold and numb as if a circulation problem, it remained there all the time in the dell but as I left it suddenly went.

I thought no more about it and eventually went back to the States.

Two months later as I drove through town another car shot a red light and hit my car broadside on the driver's side. I was badly concussed and taken to hospital.

As I was recovering the doctor came in and said that I had been extremely lucky as the car had hit mine in the only spot that offered protection to me, an inch either way and I would probably be dead, however your only injury is a badly bruised shoulder, exactly where I felt the sensation in the dell. Many thanks for a guardian angel.

Diana

(E-mail supplied).

A most striking event was in September 2006 during a ghost walk. Among the patrons in the Dell was a young girl about thirteen years old, who suddenly exclaimed without any prompting:
'What are these pretty lights dancing around me?'

This was put down to imagination, but then she began to appear as if she was trying to catch them, like you would with a floating bubble; her friend was stood outside the area waiting for her with a digital camera.

The girl then said look, I have got one in my hand, and came towards her with cupped hands. As she became close her friend took a flash photo.

The walk progressed, but after a few yards there was a pause, as a crowd gathered round the girl who had taken the photo, all talking excitably.

On the LCD it showed quite clearly the cupped hands of the girl in the bush, but hovering about 4 inches (8cm) above her hands was a beautiful multicoloured orb about the size of a golf ball. I asked them to send me a copy; unfortunately I never received it. But I can assure you, it was a very positive sighting witnessed by over fifteen people.

M. L. C

EPILOGUE

This concludes our safari into the unknown. This book will never ever be finished as new hauntings are still occurring. If you ever visit the Theatre Royal Bath, I should look carefully at the person sat next to you, and the cold draught you feel may not be the air conditioning.

REFLECTIONS

What Are You,
Who Are You,
Why Are You.

To really experience the reality of the paranormal I strongly recommend that you join the 'Ghost Walks of Bath', which starts from the 'Garrick's Head' at 8 p.m. on Thursday, Friday and Saturday.
Contact: 01225 350512. Talk to me: bathghosts@yahoo.co.uk

Take Care and **all will be well.**
Malcolm Cadey.